LONELY HEART

THE ART OF TARA McPHERSON

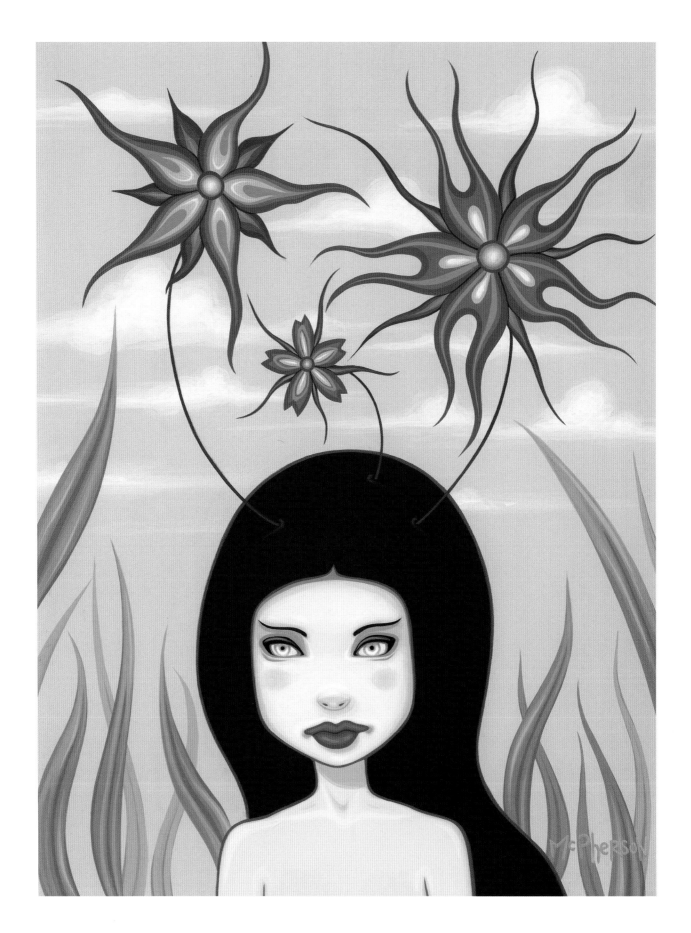

VARIATIONS ON CHERRY BLOSSOMS - acrylic on birch, 7" x 9", 2003

LONELY HEART

THE ART OF TARA McPHERSON

FOREWORD BY FRANK KOZIK

DARK HORSE BOOKS®

Milwaukie

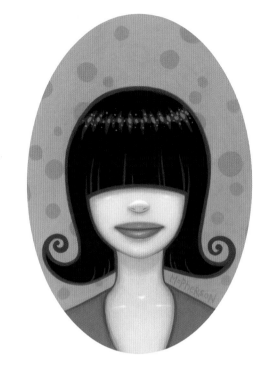

THIS BOOK IS DEDICATED TO EVERYONE
WHO HAS LOVED AND LOST.

I would like to give a very special thanks to Frank Kozik, Andy Stern and Diesel Fuel Prints, Tyna Reneé, The Bushmans, Kathy and Marc Turk, Beth and Bob Locker, The Hogans, Michael Hussar, Tim Biskup, Alan Forbes, Chuck Sperry, Ron Donovan, Shepard and Amanda Fairey, Jermaine Rogers, Justin Hampton, Leia Bell, Geoff Peveto, Clay Hayes, Eric Powell, Dave Johnson, James Jean, Jeff Soto, Gary Baseman, Lori Earley, Jordin Isip, Jonathan Weiner, Esao Andrews, Erik Foss, Nathan Cabrera, Aya Kakeda, The Pizz, PJ Fidler, Jason Holley, Aaron Smith, The Clayton Brothers, Enrique Galvez, Gen McCarthy, Jonathan Cathey, Mark Heggie, Darren Grealish, Farron Kerzner, Jessie Frances Gottlieb, Lynn Grieveldinger, Betsy Davis, Holly Johnson, Kristin Goodman, Shelly Bond, Will Dennis, Jonathan Levine, Billy Shire, Jana DesForges, Dave Kinsey, Tom Hazelmeyer, Paul Cruikshank, Poster Pop, Rough Draft Studios, William Haugh, Bruce Duff and The Knitting Factory, Donna Busch and Goldenvoice, Paul Budnitz and Kid Robot, and Chris Warner, David Scroggy, Lia Ribacchi, Mike Richardson, and everyone at Dark Horse. And to everyone else in my life, good and bad, who has helped shape who I am. I love you . . .

LONELY HEART: THE ART OF TARA McPHERSON

Publication design by Tara McPherson with Keith Wood

Dark Horse Books
10956 S.E. Main Street
Milwaukie OR 97222

darkhorse.com

taramcpherson.com

First edition: June 2006

ISBN: 978-1-59582-102-7

3 5 7 9 10 8 6 4

Printed in China

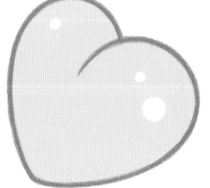

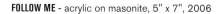

FOLLOW ME - acrylic on masonite, 5" x 7", 2006

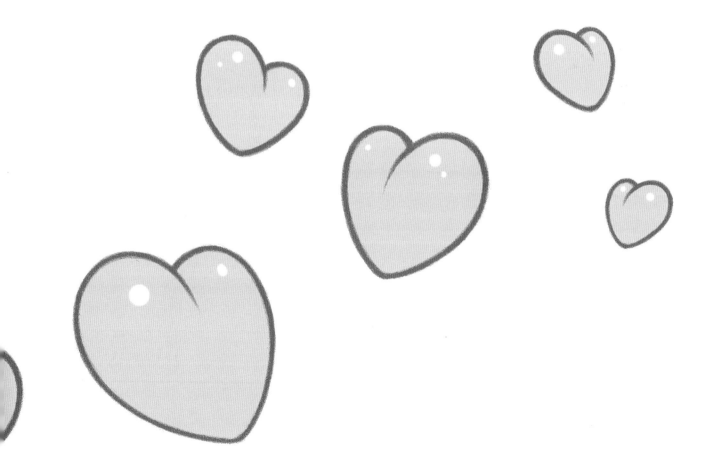

FOREWORD

It can be claimed that most Art is either an artist reflecting the culture around them or, conversely, that a culture creates a reflection called the Artist.

But, ever so rarely an artist IS the culture . . . and then transcends it.

Between 1984 and 2001, Los Angeles created a culture, a culture based on rebellion, excess, rock and roll, street glamour, and the drive for celebrity. Musicians, artists, performance artists, filmmakers, writers, cartoonists, and many other forms. Colors glowed and boundaries seemingly dissolved in a maelstrom of creativity and neon glitz . . . Lowbrow, West Coast—many names were thrown at it. Few stuck, but a new, semi-cohesive "national style" soon emerged from the stew and has crept into every facet of modern Pop Culture. Superhero movies on the big screen. Punk absorbs high fashion (or was it the other way around?). The examples are endless. Punk won. The Underground won. Suddenly, everything was Cool . . . then the culture gelled, almost overnight, into something different, something prone to create boundaries and set traps for the unwary. This culture was an incubator for an entire generation of creative individuals and an endless stream of their imitators. Things once fresh seemed trite, and rebellion seemed set in stone and utterly boring.

However . . . once in a while, a rare while, these conditions produce a truly new, fresh, and amazing person. A person who manages to navigate the shoals, absorb the energy, live the life, absorbing it all and then reaching into some place inside and producing something utterly clean, utterly new, and something utterly vibrant. Just such a person is Tara McPherson. After a few years in the belly of the beast, in that whirlwind called Los Angeles, Tara absorbed all that energy, all the disparate references, and molded a new, cohesive vision. She took Rock and Art and Comics and Fine Art and Fashion and Emotion and YOU NAME IT and distilled something that was a perfect mix of all of the above, yet completely outside it in some whimsical way.

Ever so rarely an individual manages to transcend boundaries, sidestep traps, look within, and create a novel situation in which the Artist is the creator, and therefore creates a new Culture, and a true voice is defined. I believe the works in this book represent one such voice. I have had the privilege of seeing Tara McPherson's exponentially growing talent up close, and I am repeatedly astounded by how quickly she has overcome the usual traps, clichés, and cop-outs that seem inherent in most of today's "alternative" art. What you have here is true, real-life experience and roots seamlessly fused with a perfect and almost violently individual style, seemingly simple, yet containing infinite and truly humane depth. Her Rock work is real and fresh, and she really is a Rock musician. Her comics and illustration work avoids the bland solipsism that passes for "underground comix." Her illustration skill, her hand-done technique, surpasses any digital drudgery . . . and her paintings are shining jewels of utter precision. Tara has the ability to fuse that Punk sensibility with bittersweet pastel candy. Her Art is Female without being bitter, endless depths of mystical strangeness trapped in a few deceptively simple lines or washes of paint. Art completely of the moment, yet somehow timeless and deeper with each renewed viewing. Sensual without being crass. And most amazing of all, she has just begun. I have never seen an artist grow into a true personal voice so quickly, so seemingly effortlessly, all the while never losing sight of the world around her.

I deeply believe this book you are holding is the first, tiny chapter in the life's work of what I consider one of the premiere trans-genre creative voices today. I cannot wait to see what happens next.

—**Frank Kozik**
San Francisco CA
February 2006

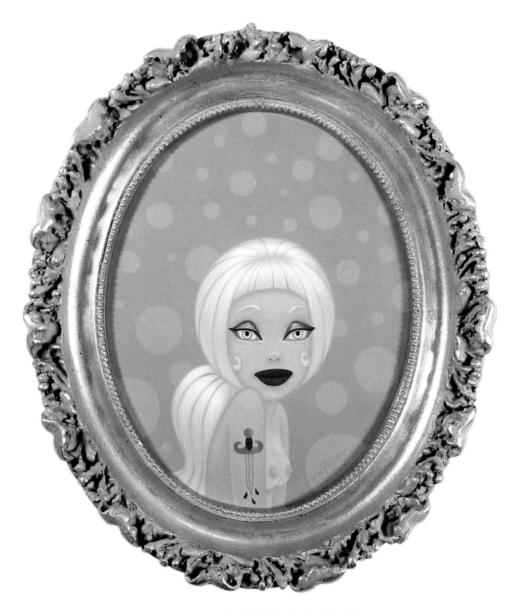

PAINTINGS

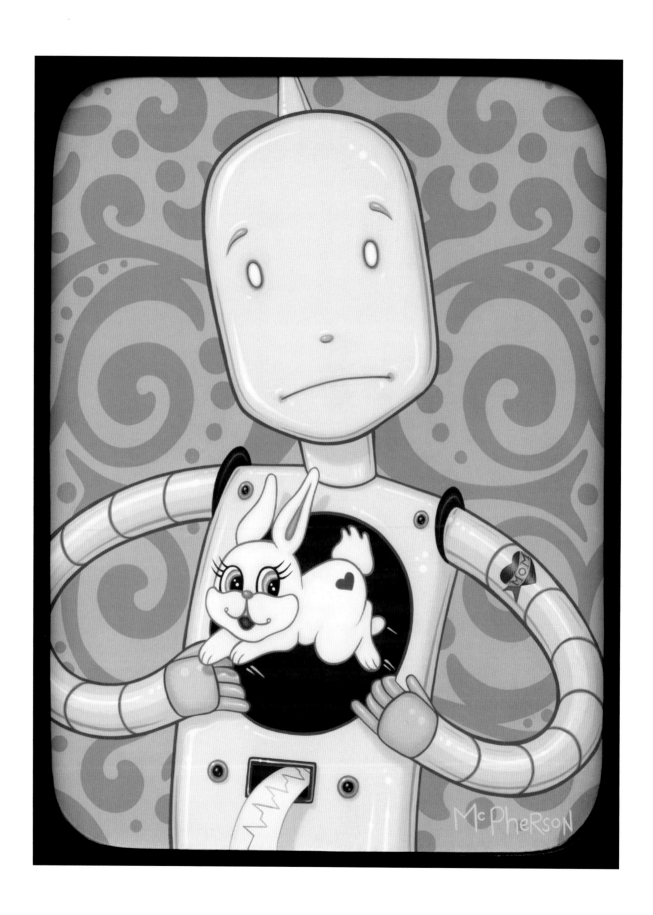

LONELY HEARTS GANG PART 2 - acrylic on birch, 8" x 10.5", 2002

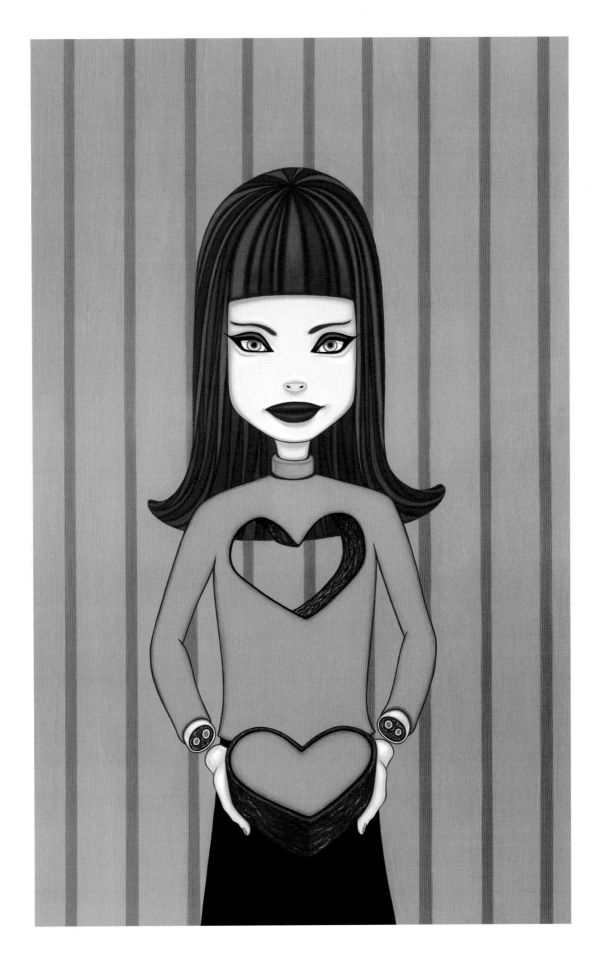

LONELY HEARTS GANG PART 1 - acrylic on birch, 9" x 13", 2002

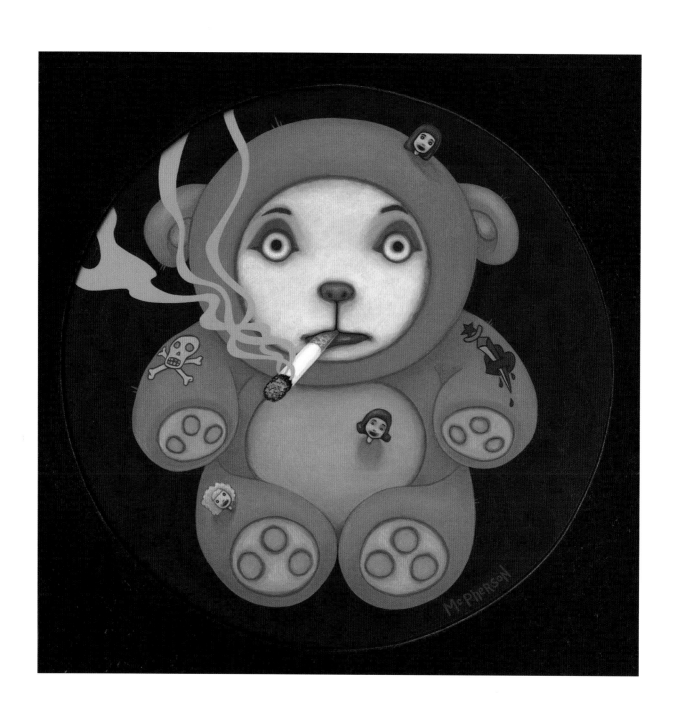

YOU FOUND WORDS TO PUT WITH SOUNDS, INCIDENTALLY YOU USED MY PEN TO WRITE THEM DOWN - acrylic and oil on birch, wooden frame, 12" x 12", 2001

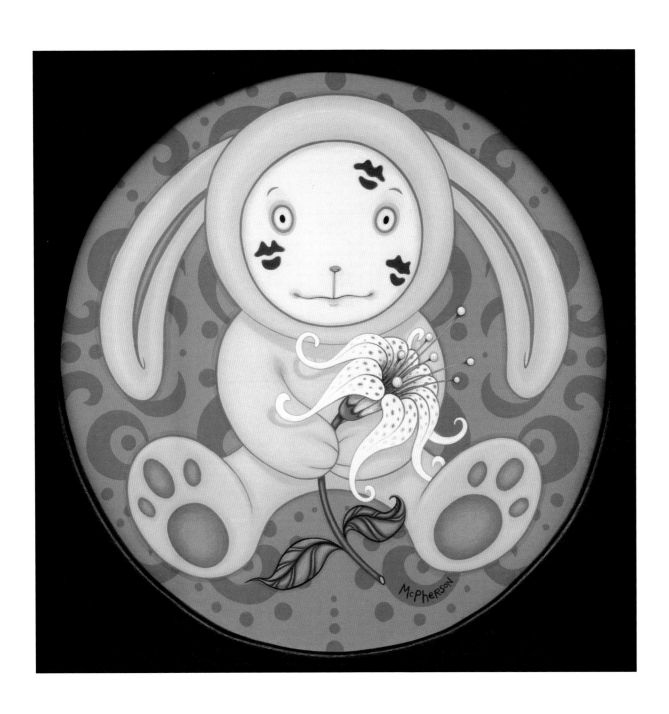

WHEN LOVERS MAKE LEAVES, IT'S THE MIND THAT SHOULD BE PLEASED - acrylic on birch, wooden frame, 12" x 12", 2001

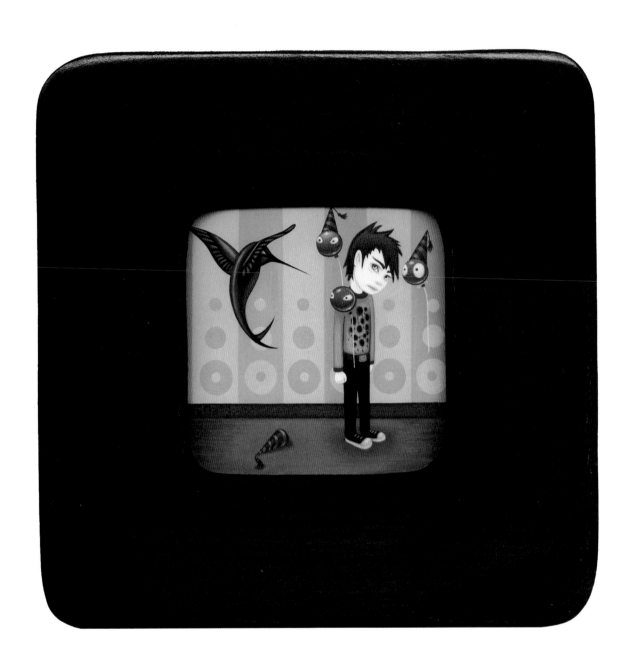

FIGHT THE FLIGHT OF ATTACK - acrylic on birch, wooden frame, 7" x 7", 2003

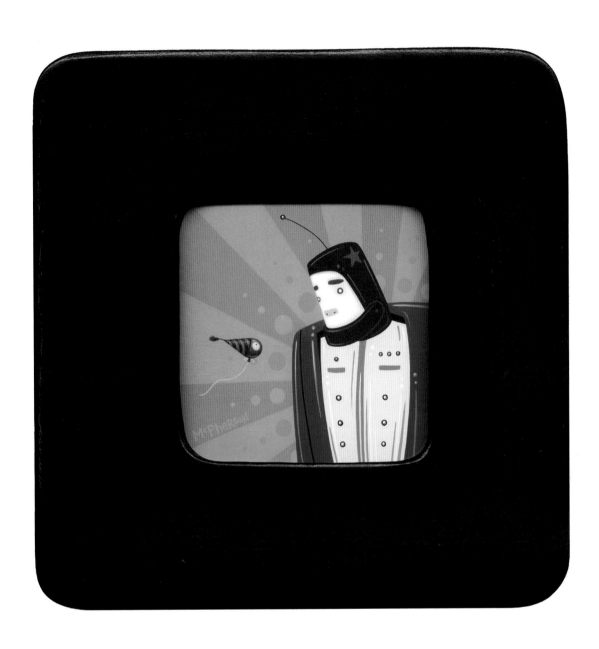

DEFEND THE FIGHT - acrylic on birch, wooden frame, 7" x 7", 2003

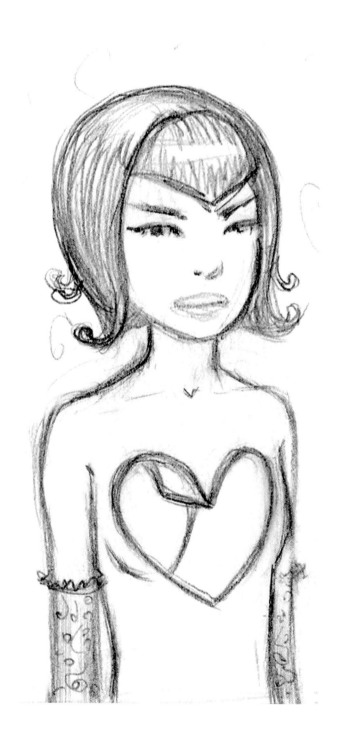

SOMETIMES I JUST WANT A HUG (rough) - graphite, 4" x 6", 2005

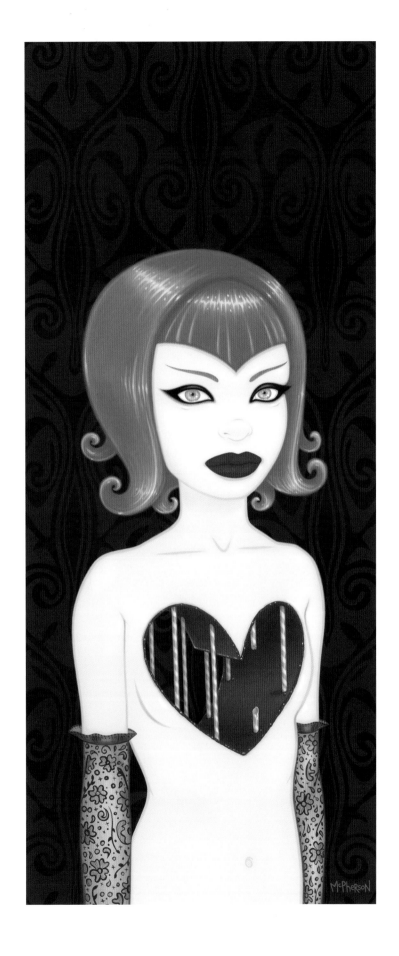

SOMETIMES I JUST WANT A HUG - acrylic on birch, 12" x 28", 2005

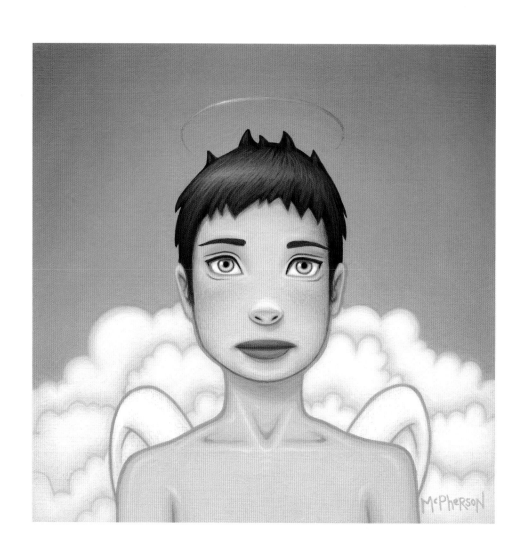

LIGHT HEARTED - acrylic and oil on birch, 5" x 5", 2002

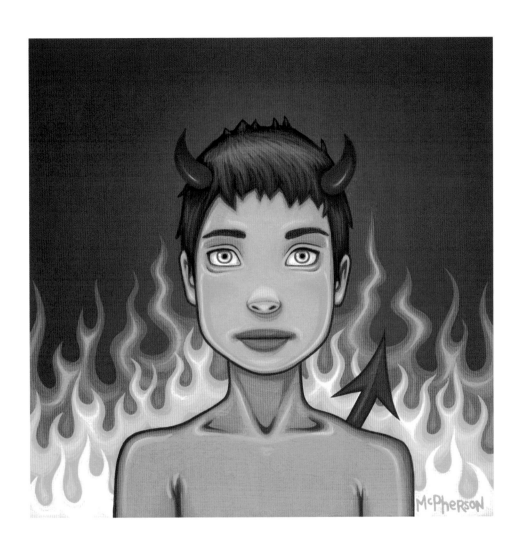

DARK HEARTED - acrylic and oil on birch, 5" x 5", 2002

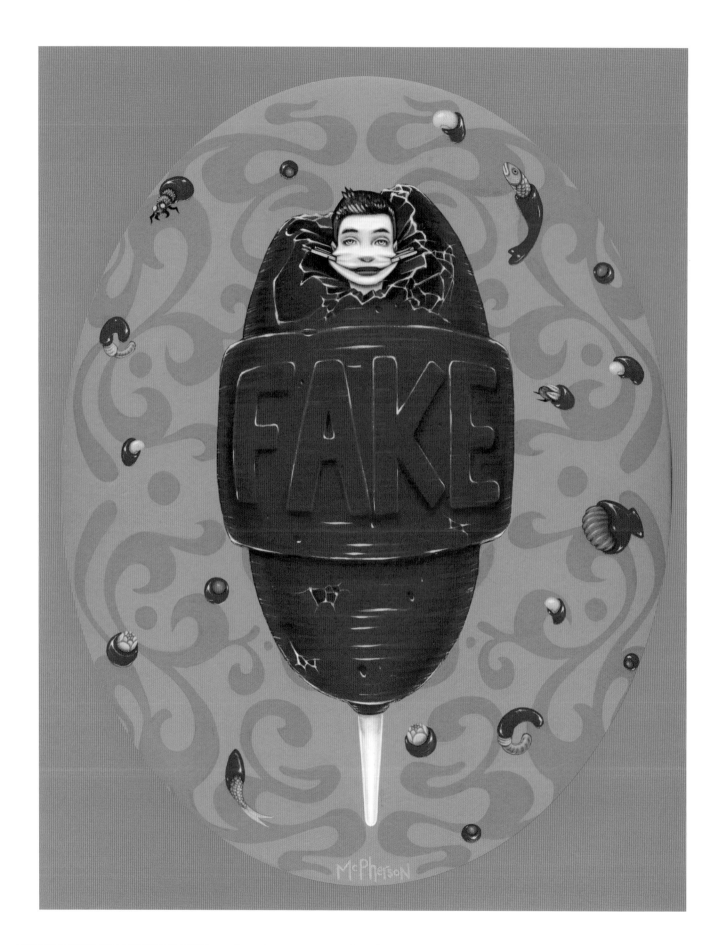

AS SWEET AS THE TONGUE I REMEMBER AS A CHILD - acrylic on illustration board, 10" x 15", 2000

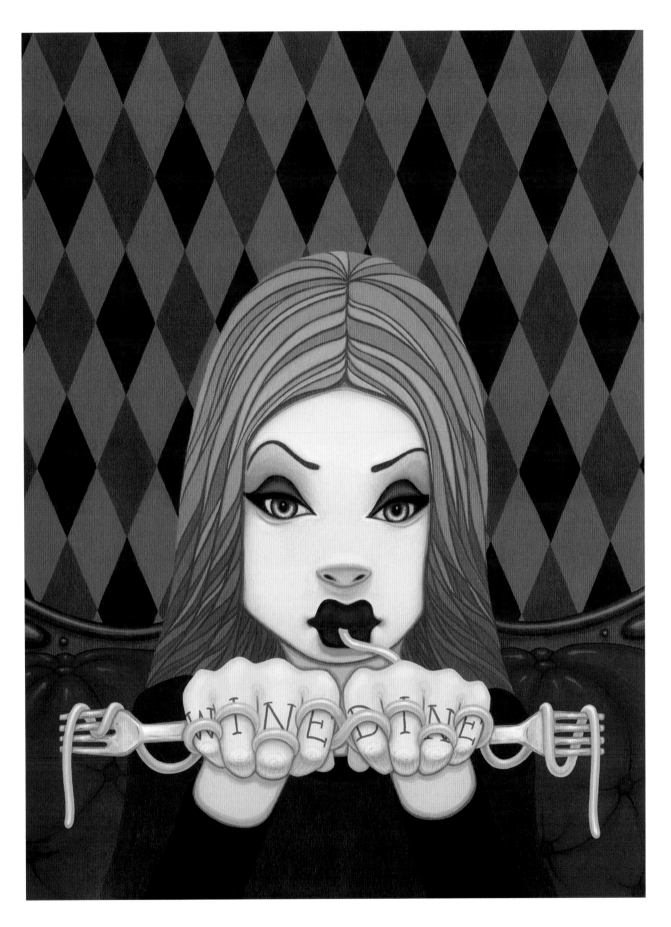

WHILE THE CATS ARE AWAY, THE MICE WILL PLAY - acrylic on illustration board, 14" x 20", 2002

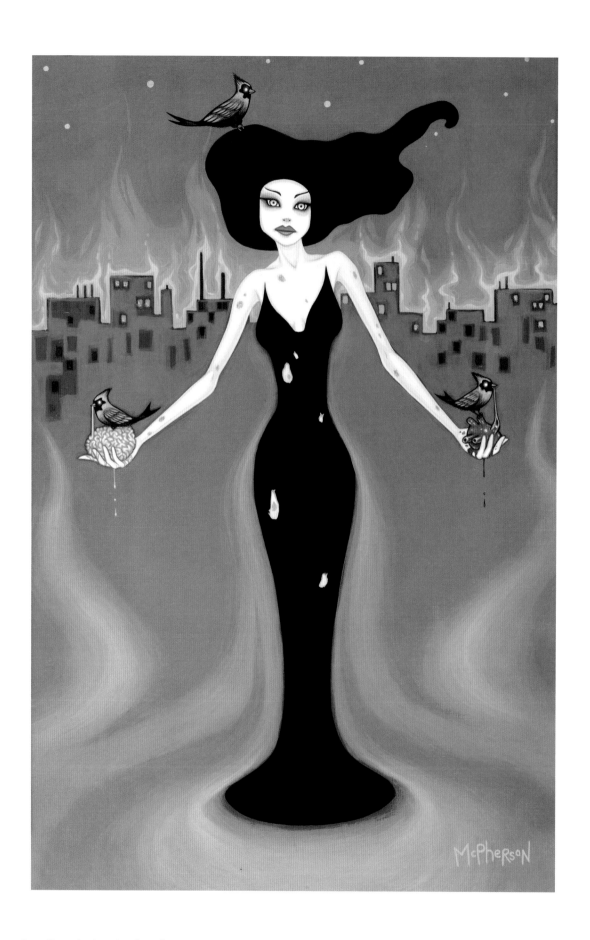

ZOMBIRELLA - acrylic on illustration board, 10" x 15", 2002

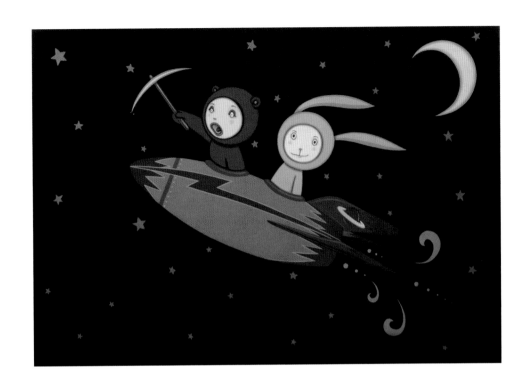

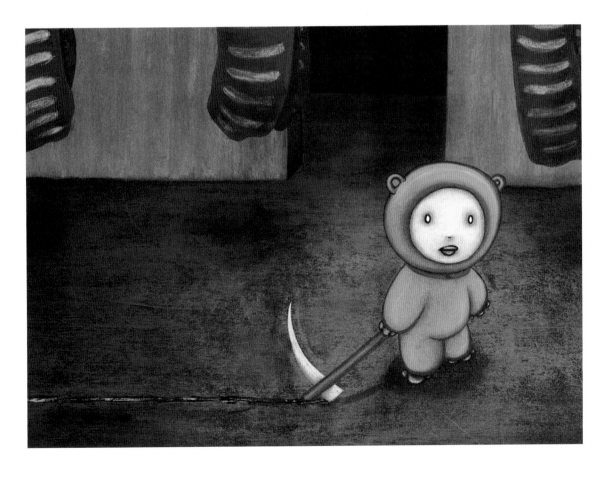

ACE AND ION GO SPACE MINING - acrylic on birch, 24" x 36", 2003
MEAT LOCKER ACE (detail) - acrylic on illustration board, 15" x 20", 2000

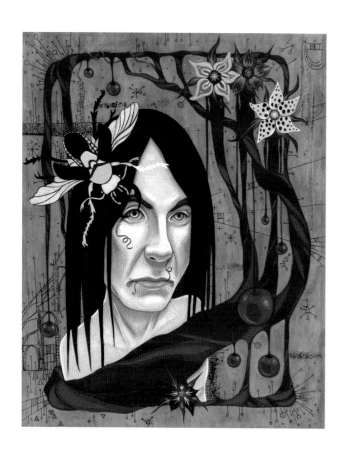 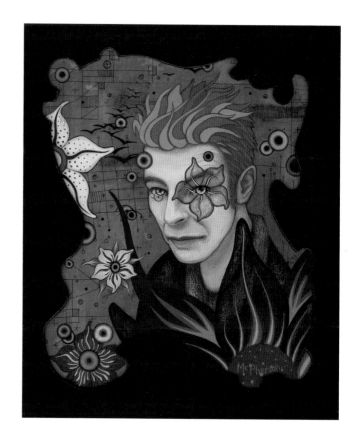

APPLE BOMB (portrait of Iggy Pop) - acrylic on illustration board, 12" x 15", 2000
EXPERIMENTATION IS THE KEY TO INDIVIDUALITY (portrait of David Bowie) - acrylic on birch, 12" x 15", 2000

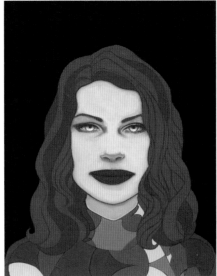
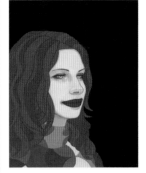

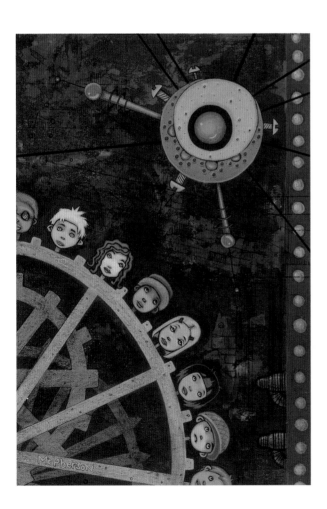

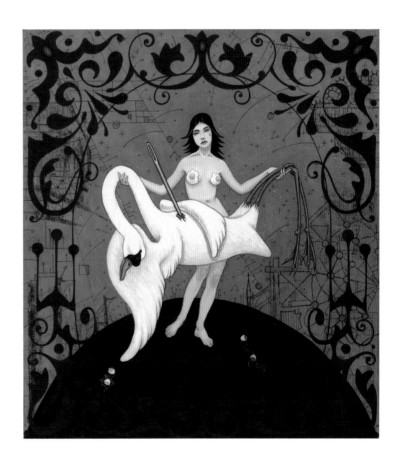

A FRIEND AS VIEWED FROM FIVE ANGLES (portrait of Betsy Davis) - acrylic on birch, 48" x 24", 2001
MY LOST CHILDREN - acrylic on illustration board, 8" x 12", 2000
LEDA TAKES MATTERS INTO HER OWN HANDS (portrait of Björk) - acrylic on birch, 12" x 15", 2000

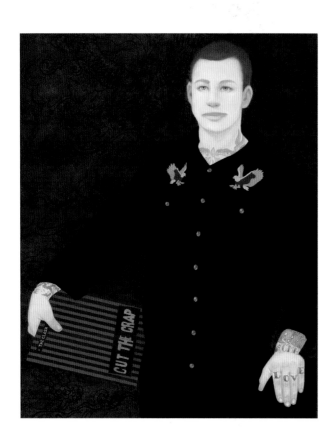 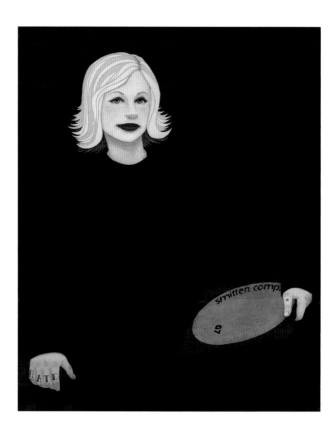

THE INTERACTION OF SEXUAL ATTRACTION PART 1 (portrait of Dave Howard) - acrylic and oil on birch, 19" x 24", 2001
THE INTERACTION OF SEXUAL ATTRACTION PART 2 (portrait of Jennifer Cavalli) - acrylic and oil on birch, 19" x 24", 2001

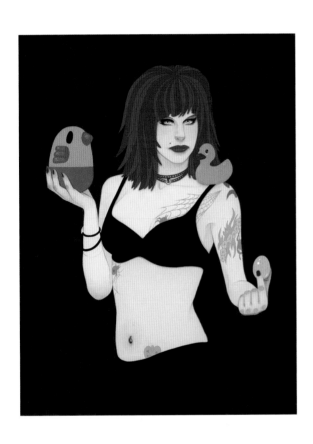
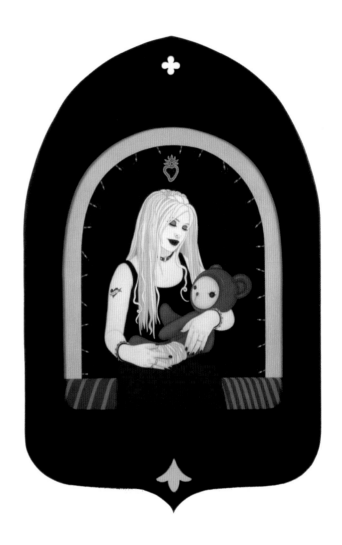

I KNEW A WOMAN WHO LOOKED LIKE A BOOKSHELF (portrait of Texas Terri) - acrylic and oil on birch, 24" x 31", 2001
THE PALLOR OF PEARL (portrait of Erin Andersen) - acrylic and oil on birch, wooden frame, 25" x 30", 2001

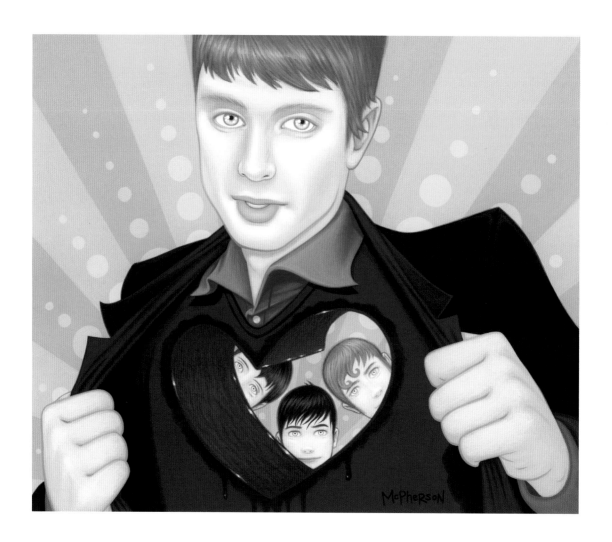

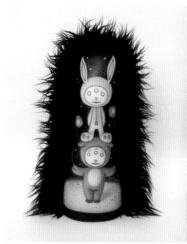

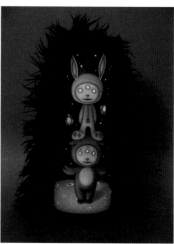

FRANZ FERDINAND (*SPIN* magazine illustration) - acrylic on birch, 9.5" x 8", 2005
BUBBLEGUM LOVE ALIEN MUNNY - acrylic on Munny, 5.5" x 7", 2005
ACE AND ION ADVENTURE #47 - acrylic on canvas Circus Punk, 6" x 14", 2005

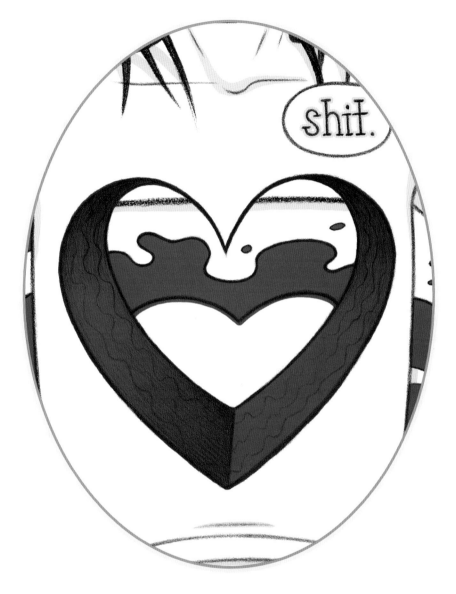

ART PRINTS

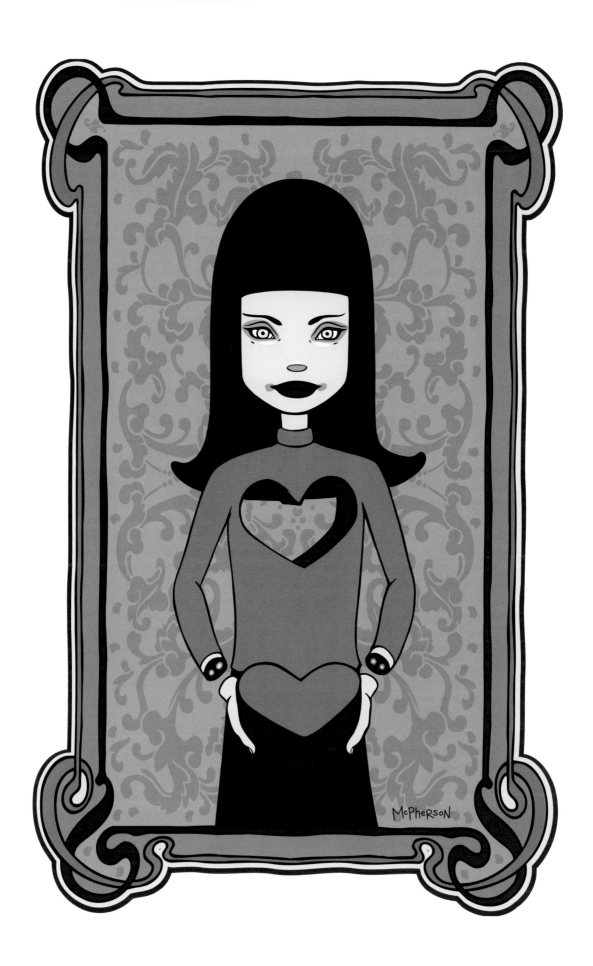

LONELY HEARTS - seven-color silkscreen, 20" x 28", edition of 100, 2004

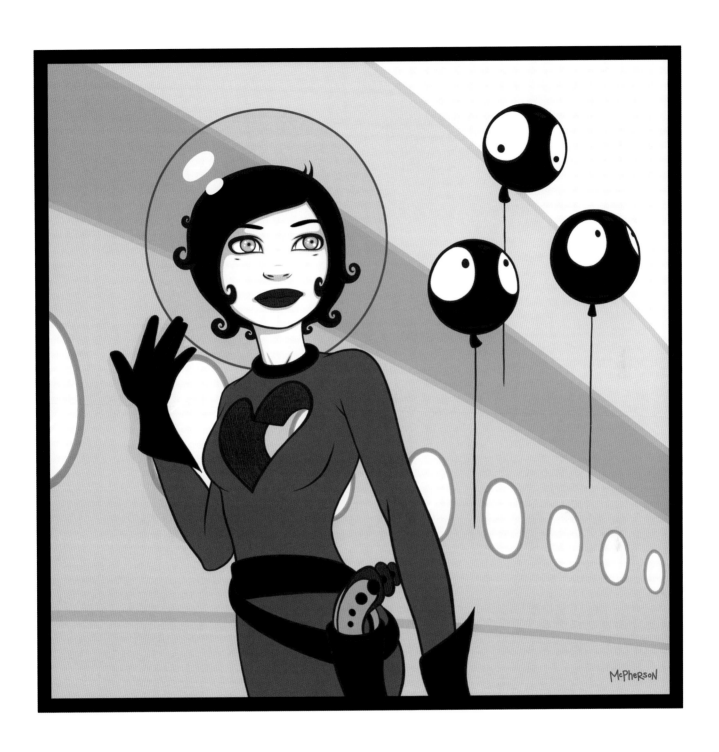

THE DULL SOUND - fourteen-color silkscreen, 20" x 20", edition of 100, 2005

LOVES LOST LUST (rough) - graphite, 3" x 5", 2003

32

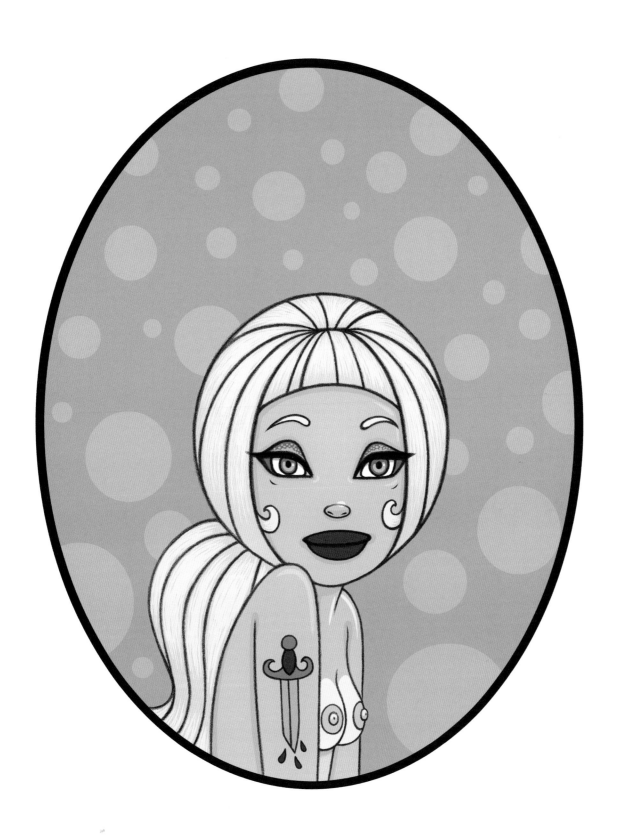

LOVE'S LOST LUST - ten-color silkscreen, 16" x 20", edition of 100, 2004

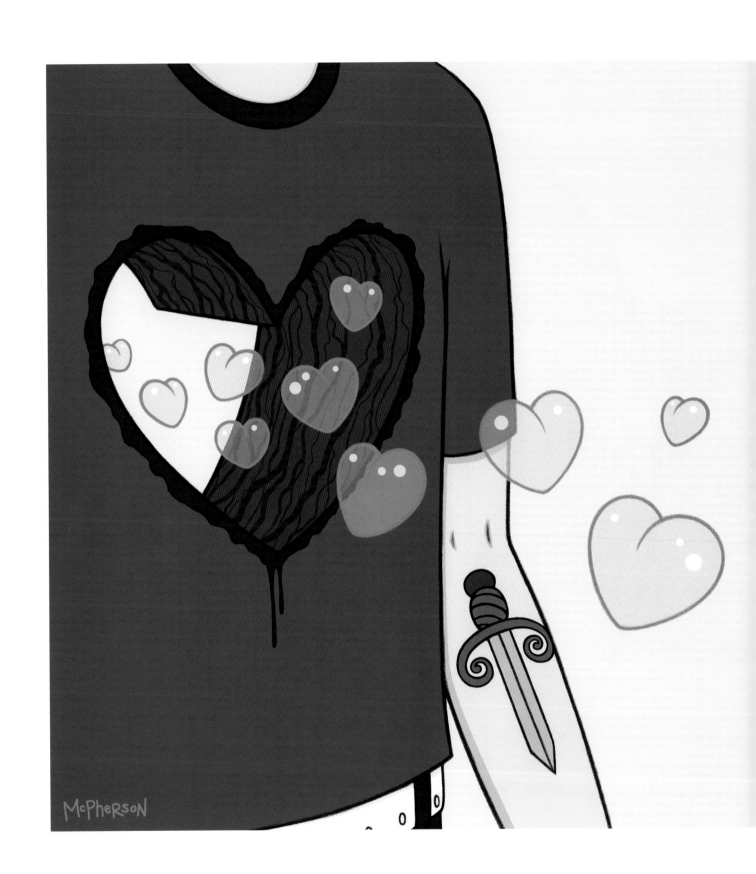

LOVE BLOWS - eleven-color silkscreen, 32" x 20", edition of 100, 2005

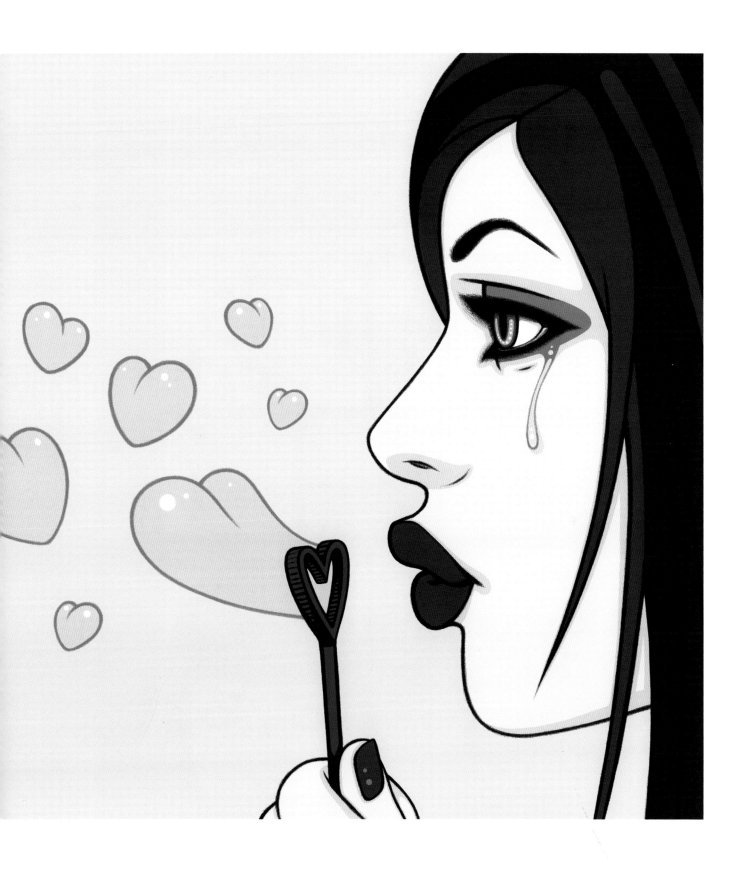

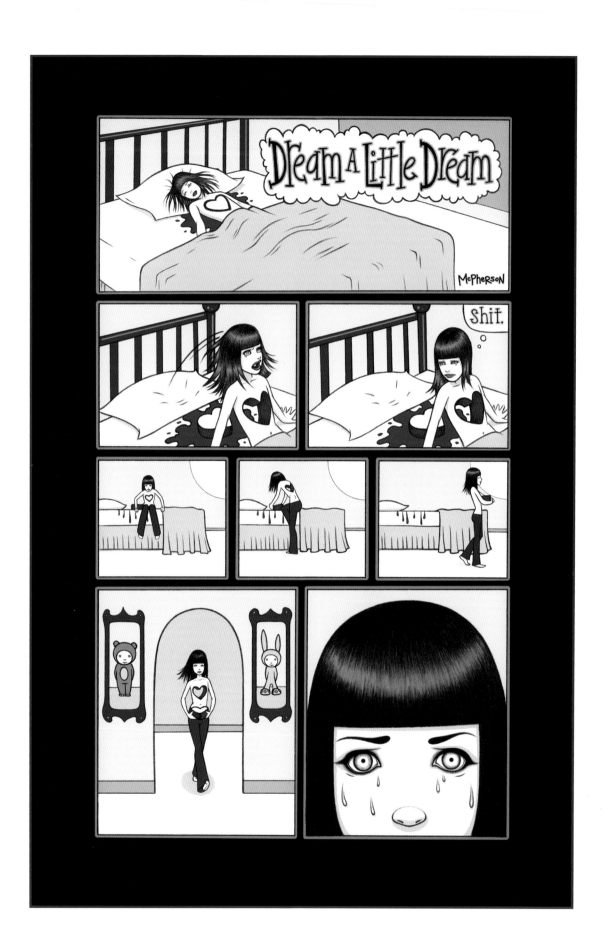

DREAM A LITTLE DREAM (*Project: Superior*) - seven-color silkscreen, 15" x 20", edition of 100, 2005

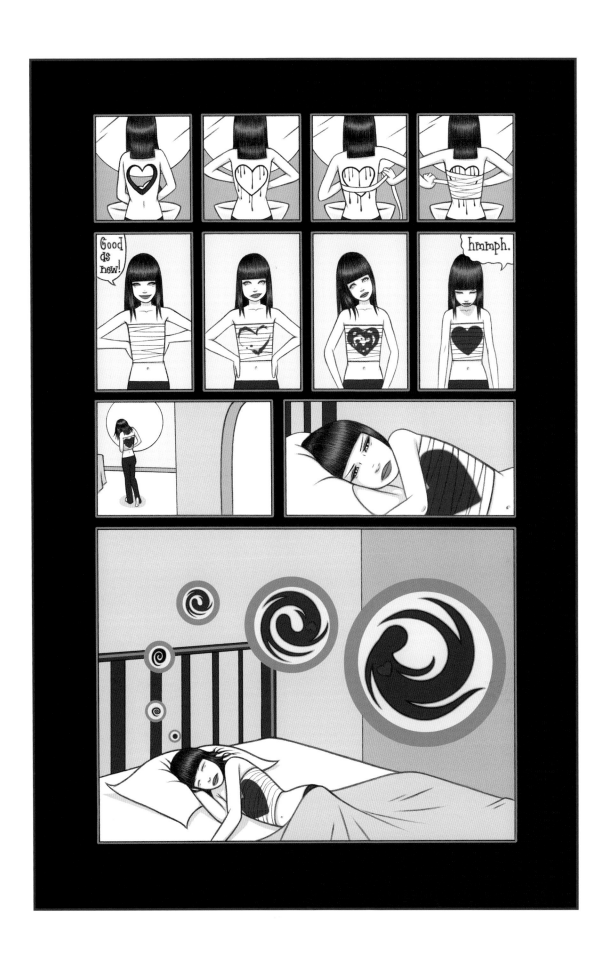

DREAM A LITTLE DREAM (*Project: Superior*) - seven-color silkscreen, 15" x 20", edition of 100, 2005

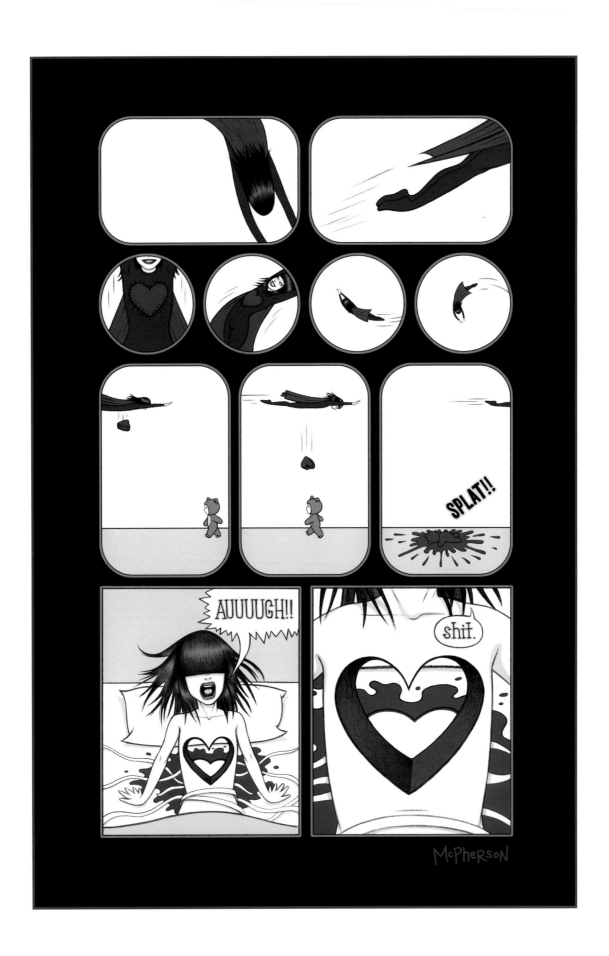

DREAM A LITTLE DREAM (*Project: Superior*) - seven-color silkscreen, 15" x 20", edition of 100, 2005

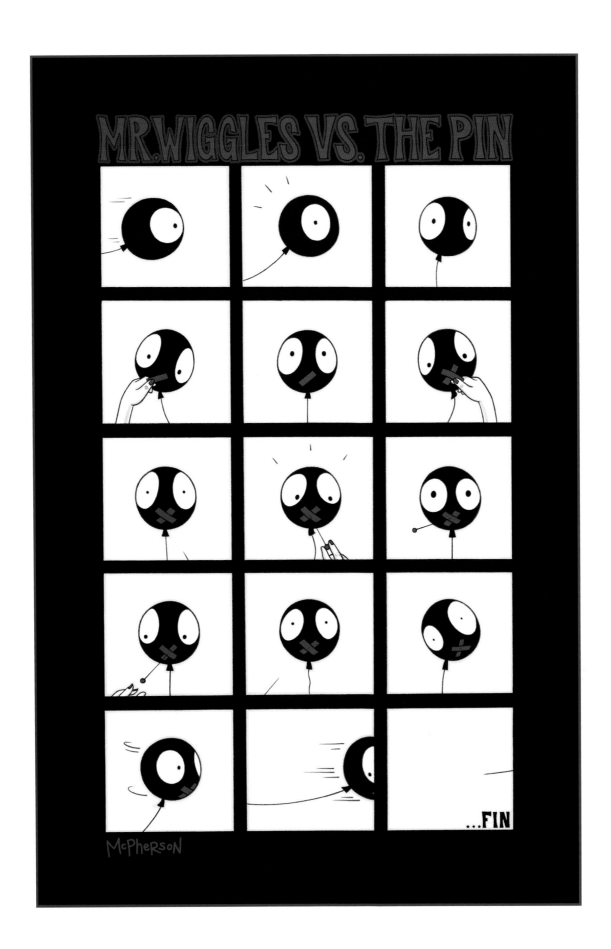

MR. WIGGLES VS. THE PIN (*Project: Superior*) - four-color silkscreen, 15" x 20", edition of 100, 2005

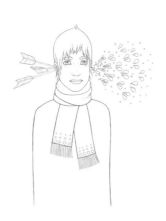
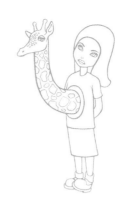
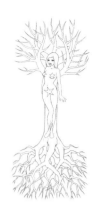

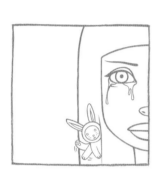
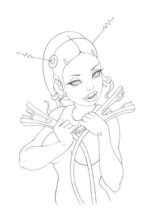
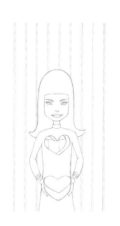
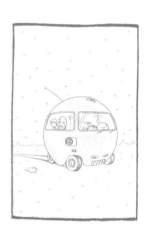

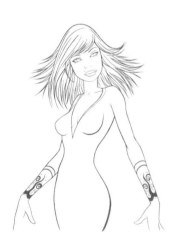

BEE LADY - one-color silkscreen, 15" x 20", edition of 100, 2005
BOY AND ARROW - one-color silkscreen, 15" x 20", edition of 100, 2005
GIRAFFE GIRL - one-color silkscreen, 16" x 20", edition of 100, 2005
TREE LADY - one-color silkscreen, 14" x 20", edition of 100, 2005
BUBBLEGUM TEARS - one-color silkscreen, 20" x 20", edition of 100, 2005
JUMPER CABLE GIRL - one-color silkscreen, 15" x 20", edition of 100, 2005
LONELY HEART DRAWING - one-color silkscreen, 14" x 20", edition of 100, 2005
ORANGEMOBILE - one-color silkscreen, 14.5" x 20", edition of 100, 2005
SEXY LADY - one-color silkscreen, 15" x 20", edition of 100, 2005
SNOW GIRL - one-color silkscreen, 15" x 20", edition of 100, 2005
SPACE BOY - one-color silkscreen, 15" x 20", edition of 100, 2005
ACE AND ION GO SPACE MINING - one-color silkscreen, 15" x 20", edition of 100, 2005

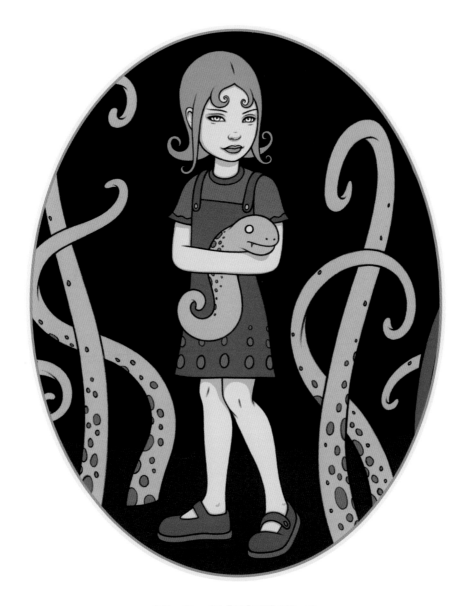

POSTERS

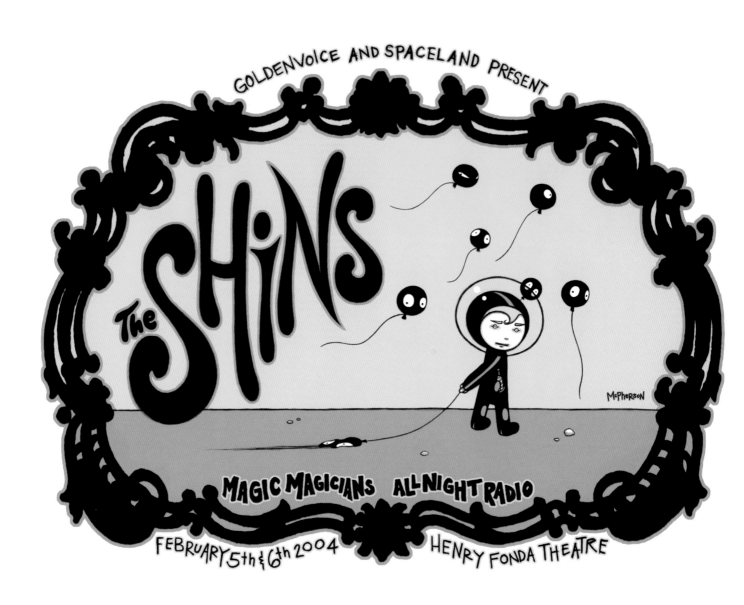

THE SHINS, MAGIC MAGICIANS, ALL NIGHT RADIO - three-color silkscreen, 16" x 23", edition of 200, 2004

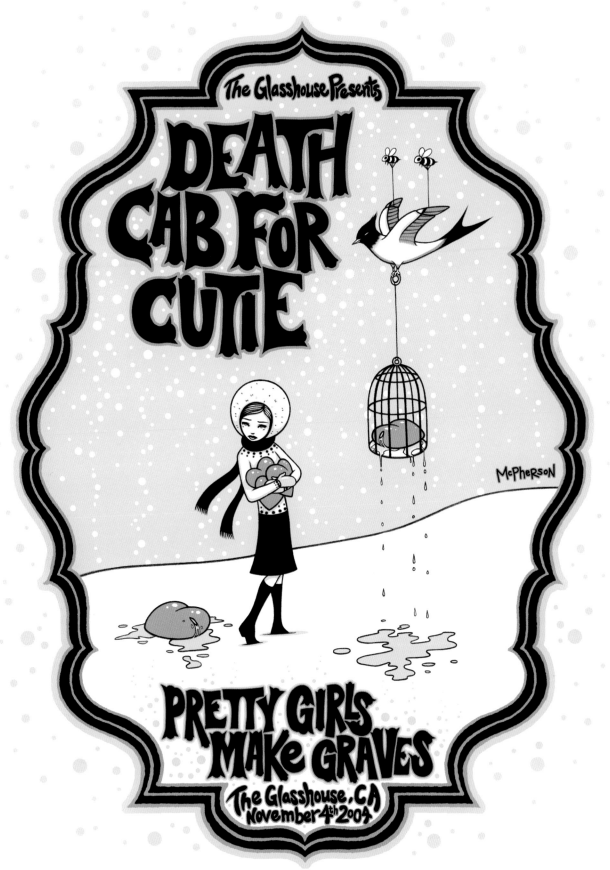

DEATH CAB FOR CUTIE, PRETTY GIRLS MAKE GRAVES - three-color silkscreen, 16" x 23", edition of 400, 2004

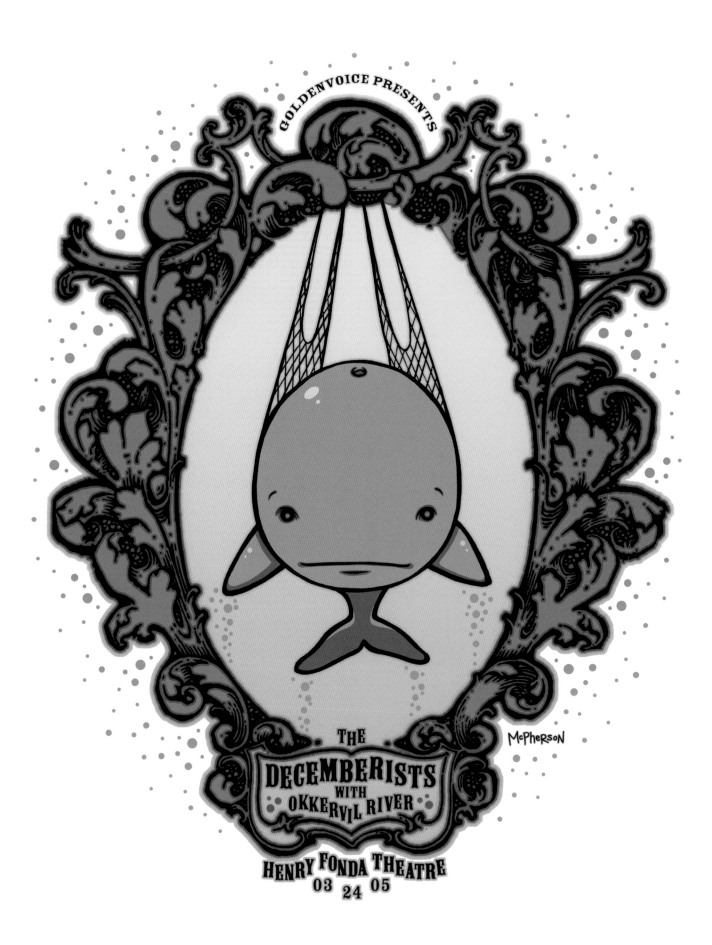

THE DECEMBERISTS, OKKERVIL RIVER - five-color silkscreen, 24" x 29", edition of 300, 2005

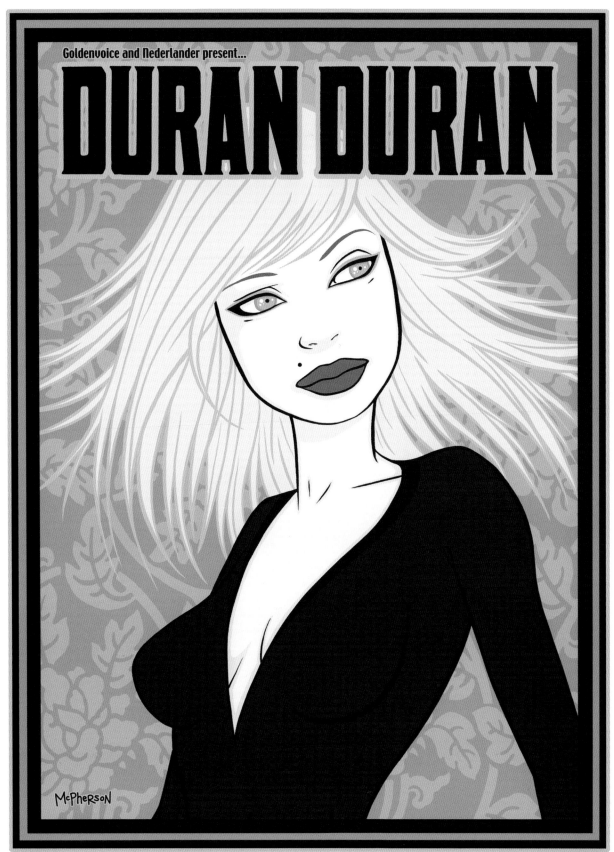

DURAN DURAN - eight-color silkscreen, 23" x 32", edition of 400, 2005

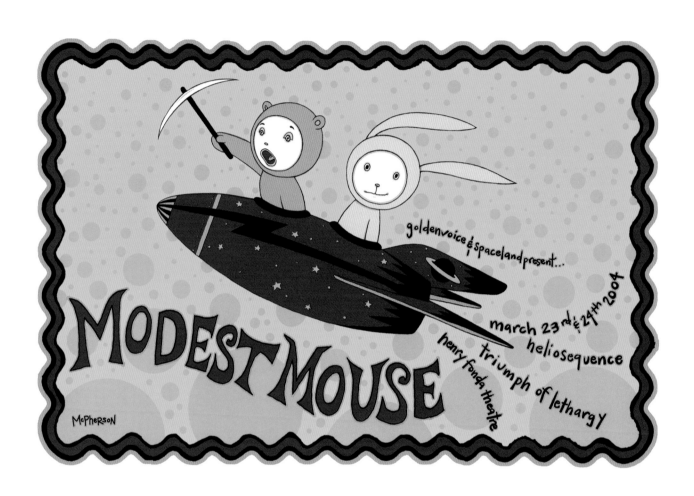

MODEST MOUSE, HELIOSEQUENCE, TRIUMPH OF LETHARGY - six-color silkscreen, 16" x 23", edition of 250, 2004

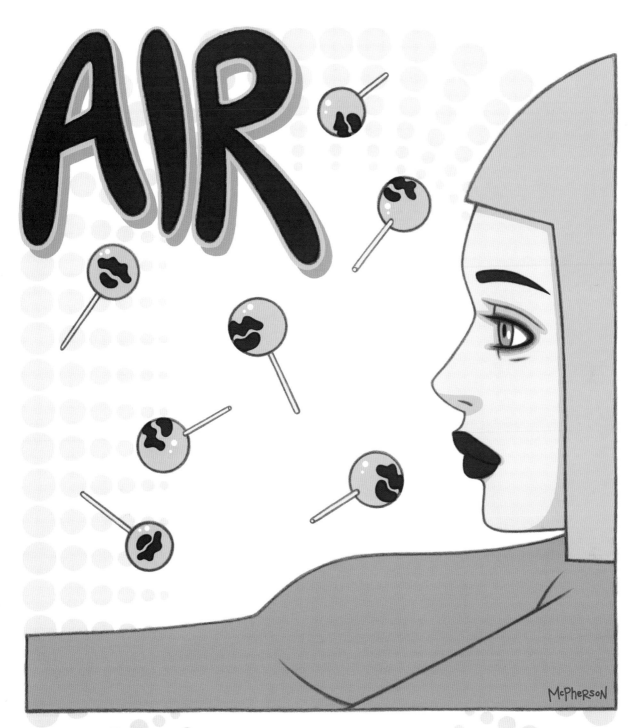

AIR, STEREOLAB, SONDRE LERCHE - six-color silkscreen, 23" x 32", edition of 200, 2004

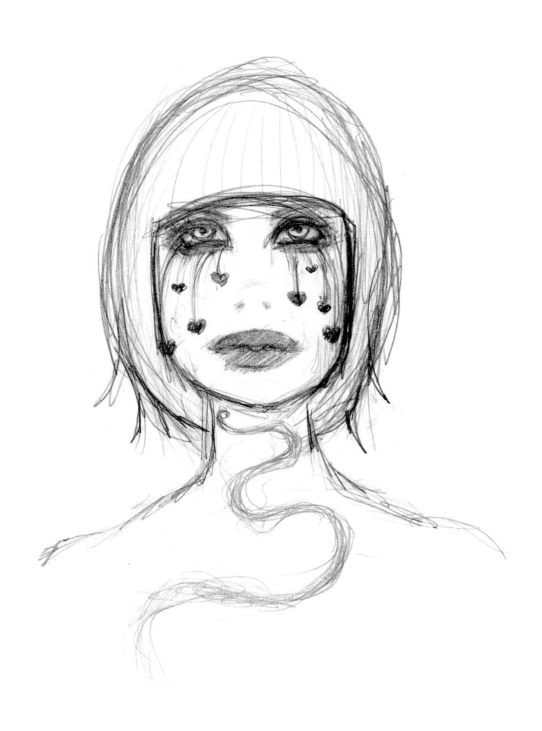

DEPECHE MODE (rough) - graphite, 8.5" x 11", 2005

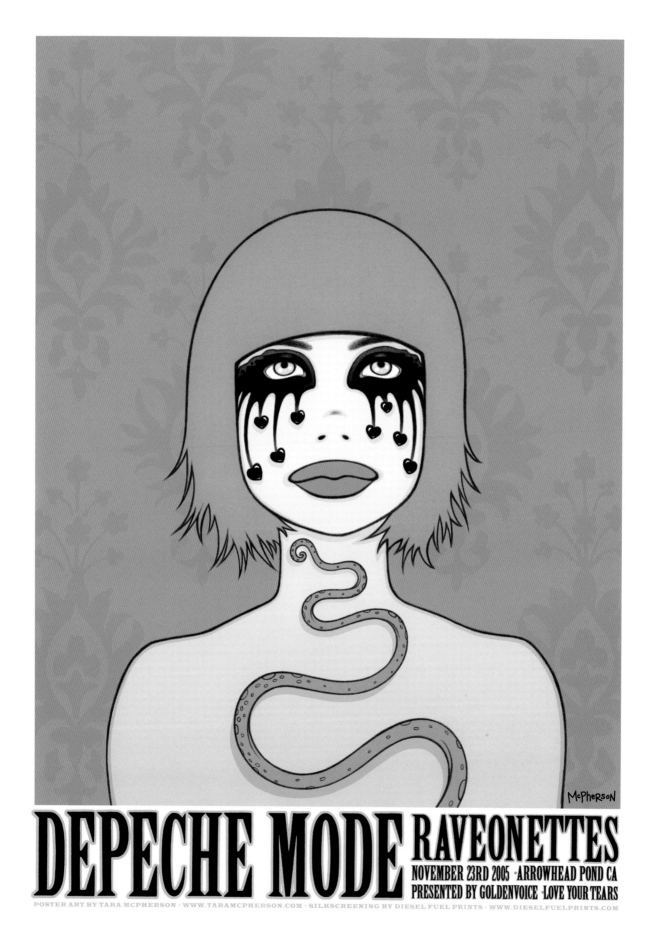

DEPECHE MODE, RAVEONETTES - five-color silkscreen, 23" x 32", edition of 235, 2005

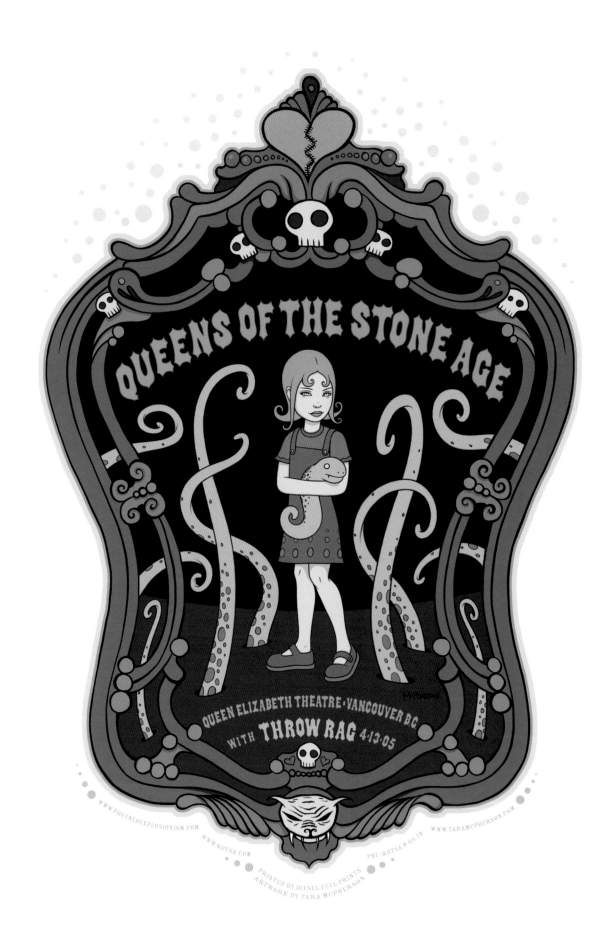

QUEENS OF THE STONE AGE, THROW RAG - nine-color silkscreen, 23" x 32", edition of 250, 2005

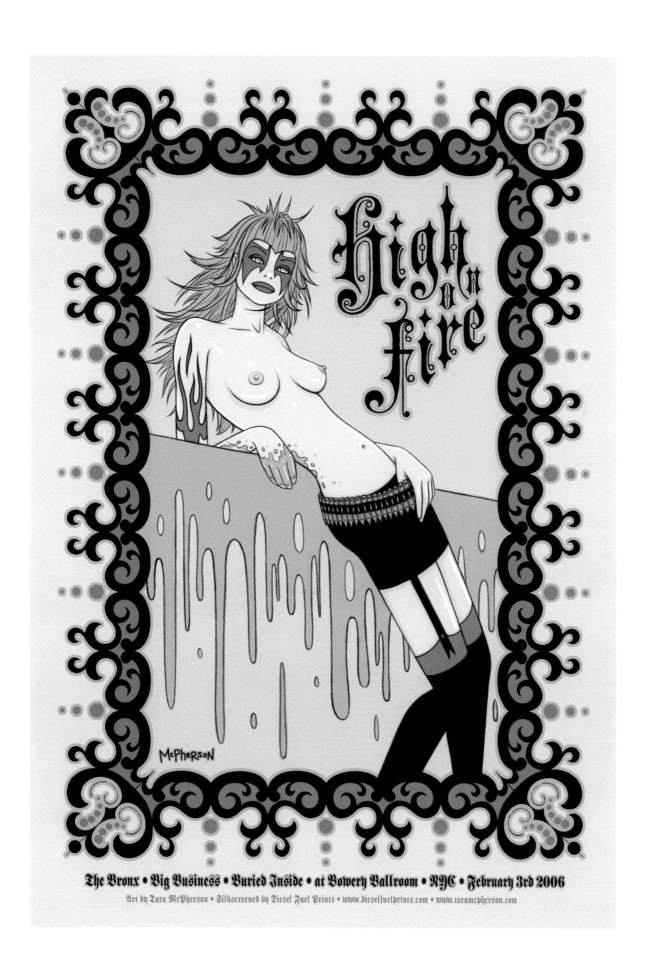

The Bronx • Big Business • Buried Inside • at Bowery Ballroom • NYC • February 3rd 2006
Art by Tara McPherson • Silkscreened by Diesel Fuel Prints • www.dieselfuelprints.com • www.taramcpherson.com

HIGH ON FIRE - five-color silkscreen, 16" x 23", edition of 300, 2006

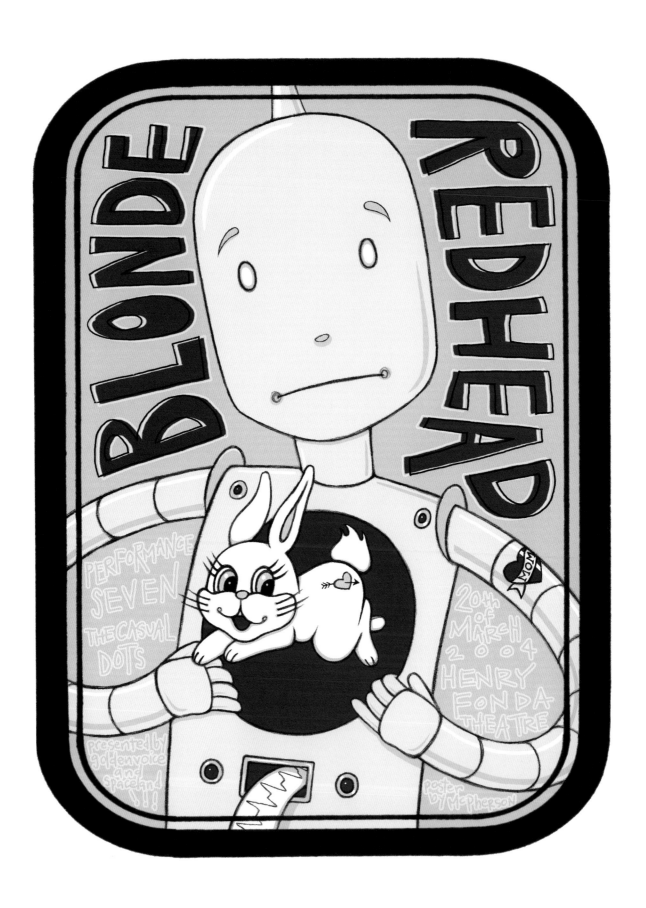

BLONDE REDHEAD, PERFORMANCE SEVEN, THE CASUAL DOTS - four-color silkscreen, 16" x 21", edition of 300, 2004

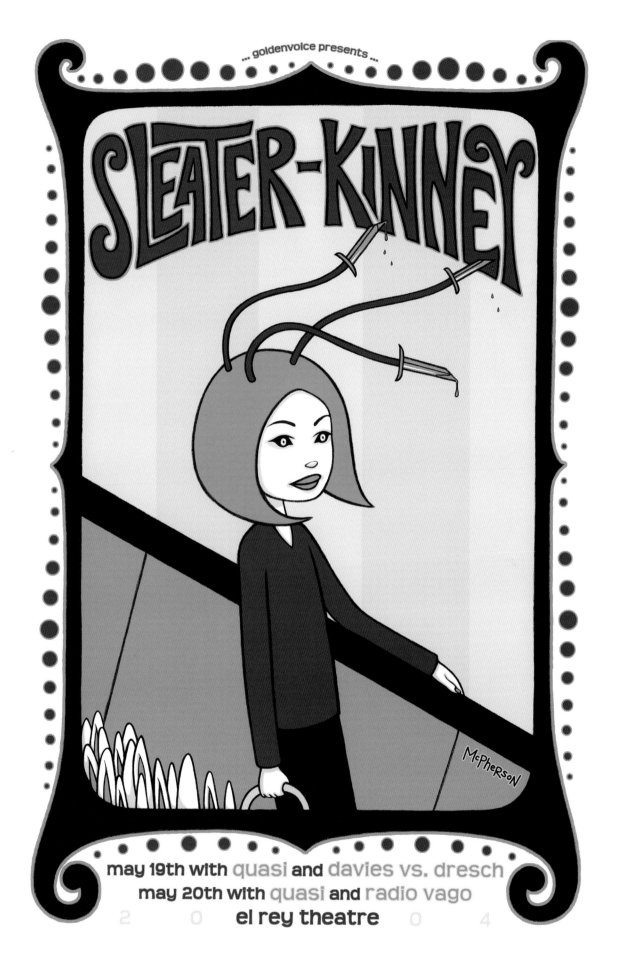

SLEATER-KINNEY, QUASI, DAVIES VS. DRESCH - six-color silkscreen, 16" x 23", edition of 400, 2004

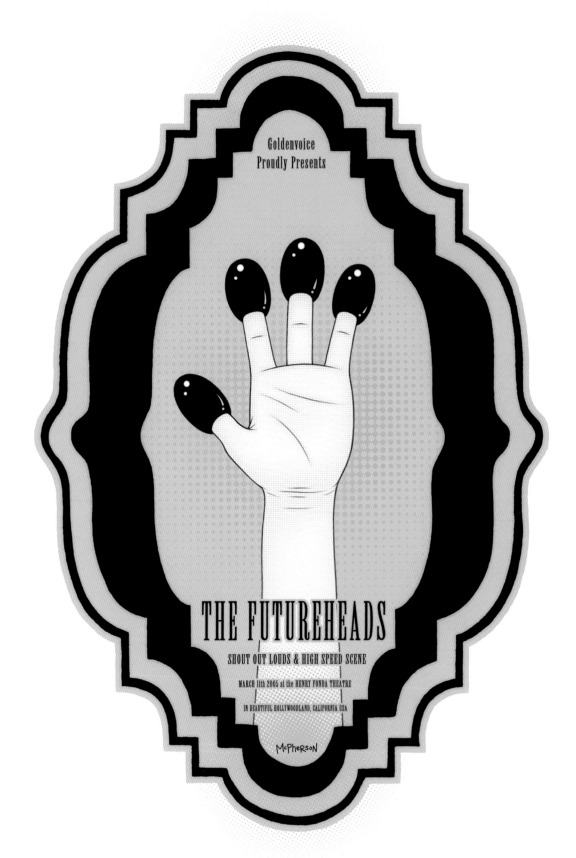

THE FUTUREHEADS, SHOUT OUT LOUDS, HIGH SPEED SCENE - four-color silkscreen, 16" x 23", edition of 300, 2005

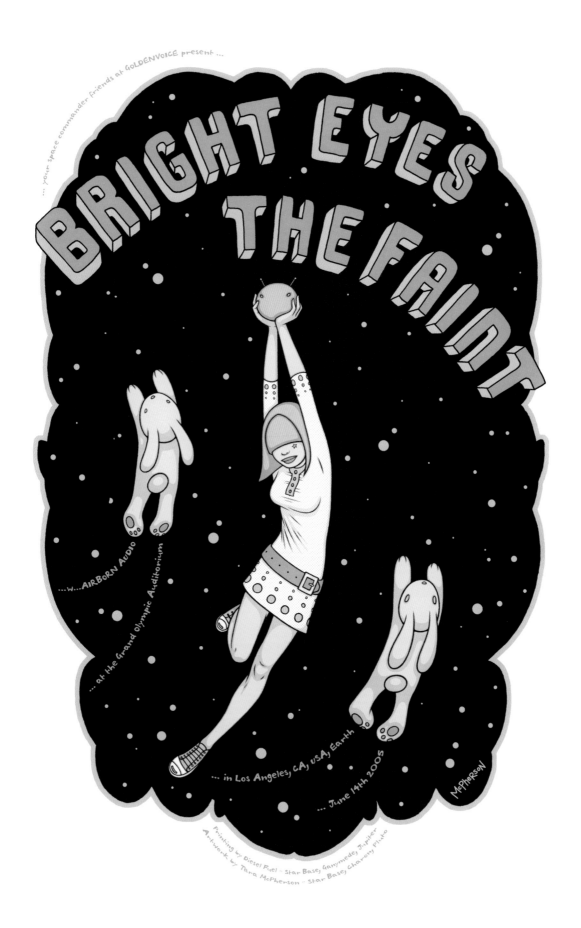

BRIGHT EYES, THE FAINT - five-color silkscreen, 17" x 24", edition of 300, 2005

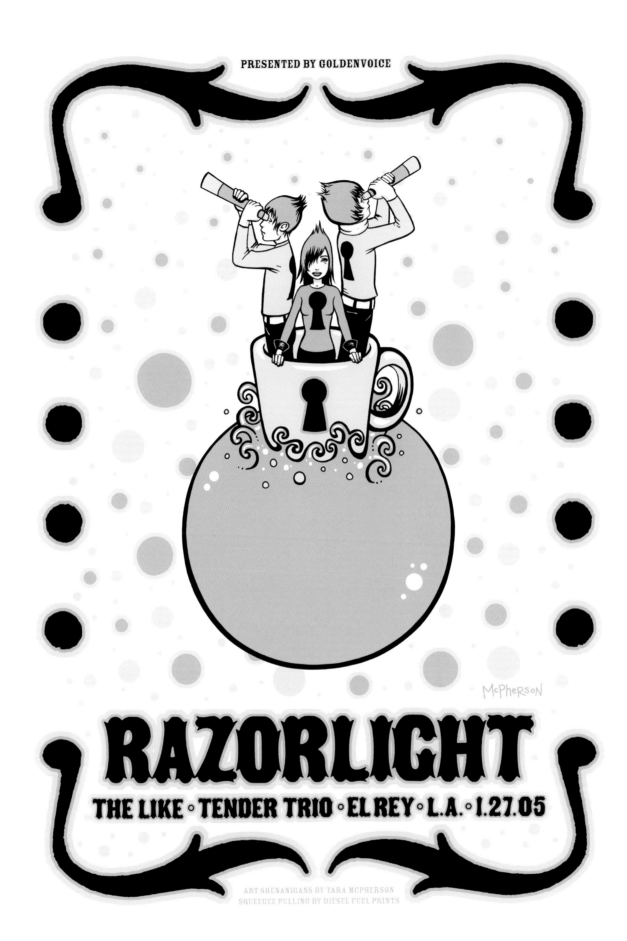

RAZORLIGHT, THE LIKE, TENDER TRIO - three-color silkscreen, 16" x 23", edition of 300, 2005

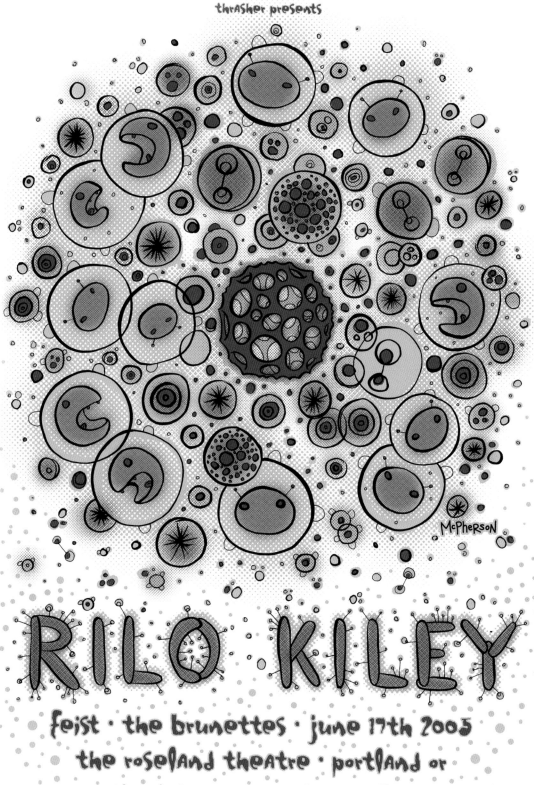

thrasher presents

RILO KILEY

feist · the brunettes · june 17th 2005
the roseland theatre · portland or

radiolarian doodlings by tara mcpherson · macro micro silkscreening by diesel fuel prints
dedicated to ernst haeckel and his microscope

RILO KILEY, FEIST, THE BRUNETTES - three-color silkscreen, 16" x 23", edition of 300, 2005

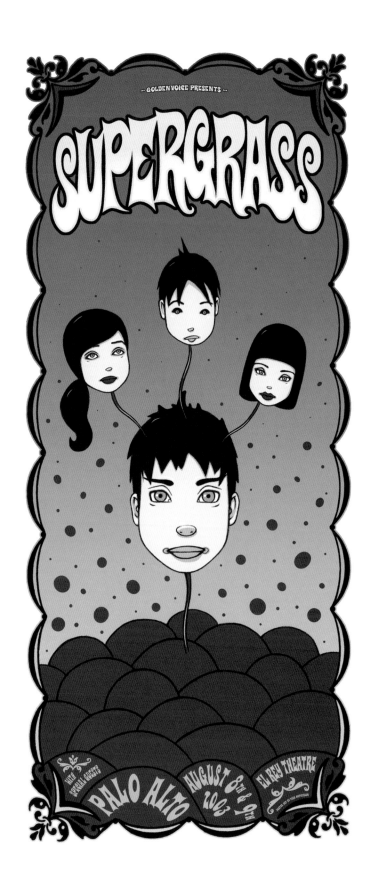

SUPERGRASS, PALO ALTO - four-color silkscreen, 10.5" x 24", edition of 200, 2003

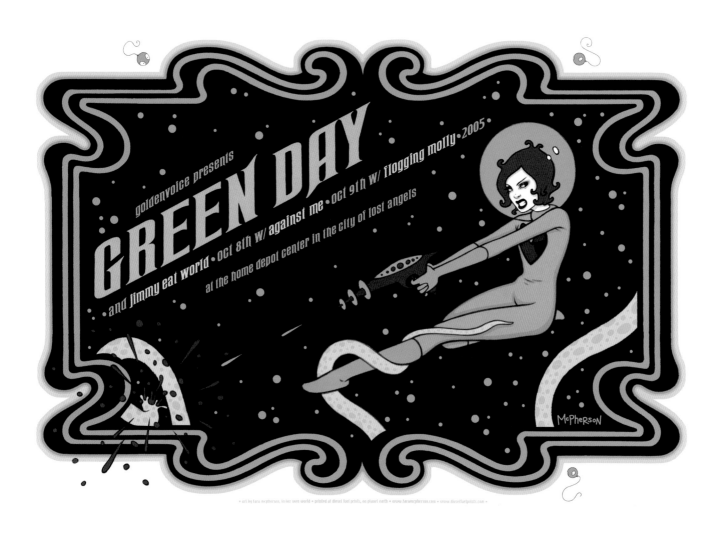

GREEN DAY, JIMMY EAT WORLD, AGAINST ME, FLOGGING MOLLY - five-color silkscreen, 23" x 16", edition of 225, 2005

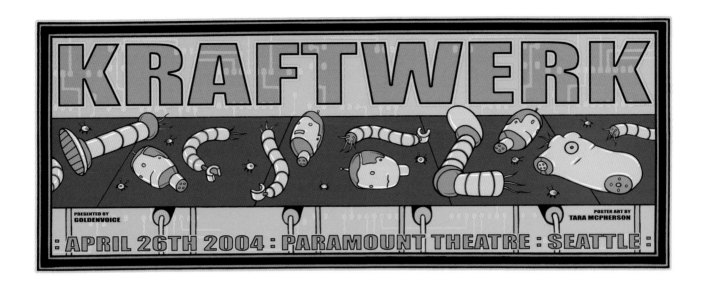

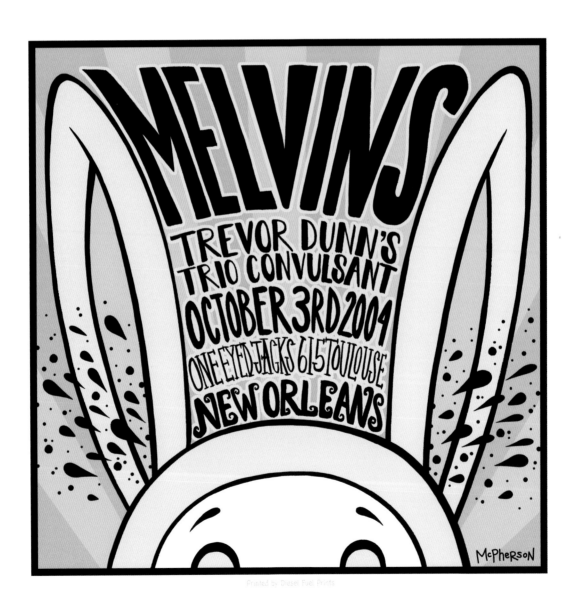

KRAFTWERK - four-color silkscreen, 25" x 11", edition of 325, 2004
MELVINS, TREVOR DUNN'S TRIO CONVULSANT - four-color silkscreen, 16" x 16", edition of 200, 2004

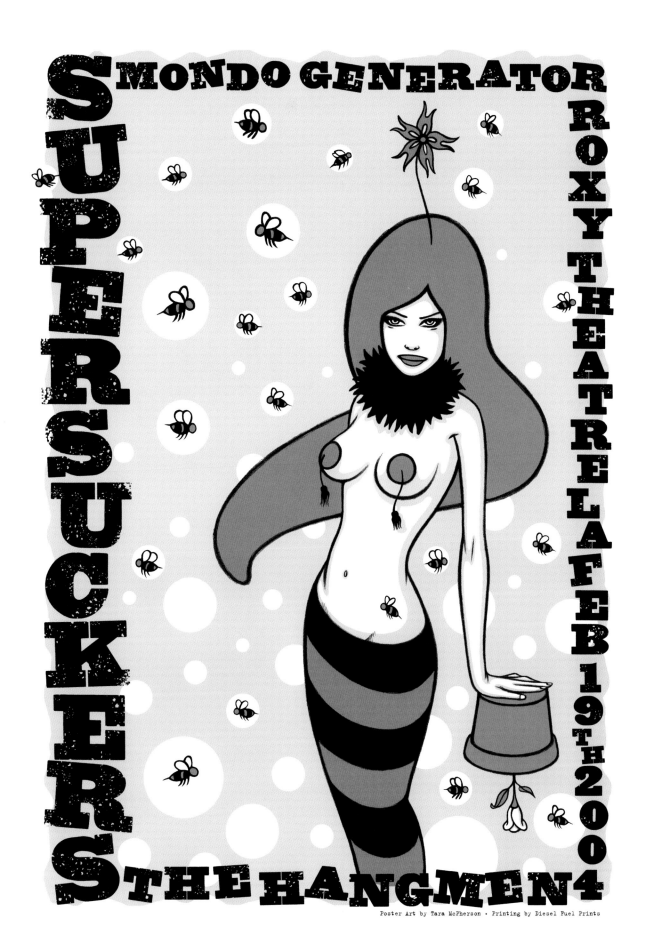

SUPERSUCKERS, MONDO GENERATOR, THE HANGMEN - three-color silkscreen, 16" x 23", edition of 160, 2004

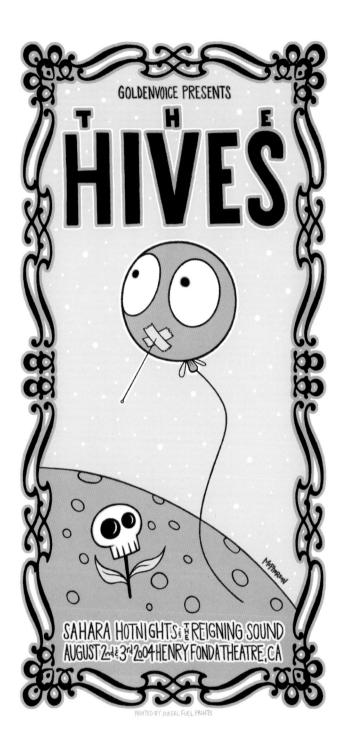

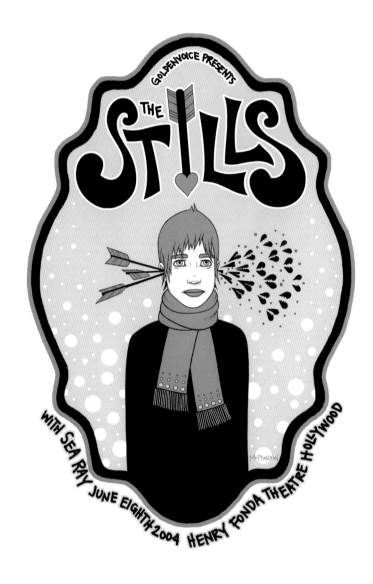

THE HIVES, SAHARA HOTNIGHTS, THE REIGNING SOUND - three-color silkscreen, 12" x 23", edition of 400, 2004
THE STILLS, SEA RAY - three-color silkscreen, 16" x 23", edition of 300, 2004

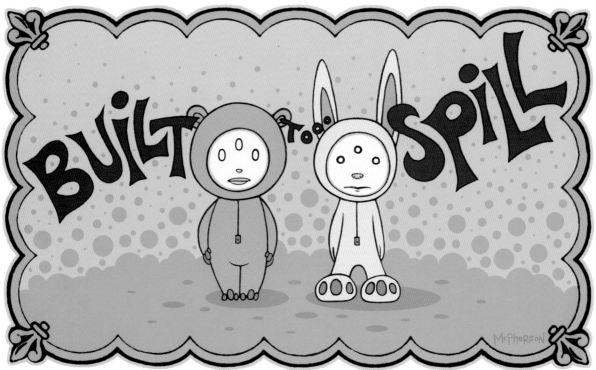

with **SOLACE BROTHERS** october 10th at Free Bird Cafe in Jacksonville, FL

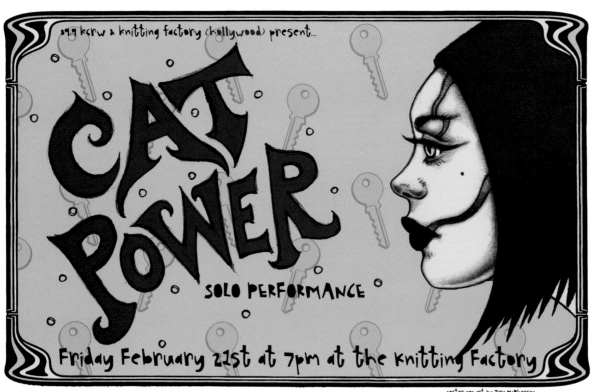

BUILT TO SPILL, SOLACE BROTHERS - offset print, 11" x 17", edition of 300, 2003
CAT POWER - offset print, 11" x 17", edition of 300, 2003

ALL TOMORROW'S PARTIES: CURATED BY THE MARS VOLTA (rough)- graphite, 8.5" x 11", 2005

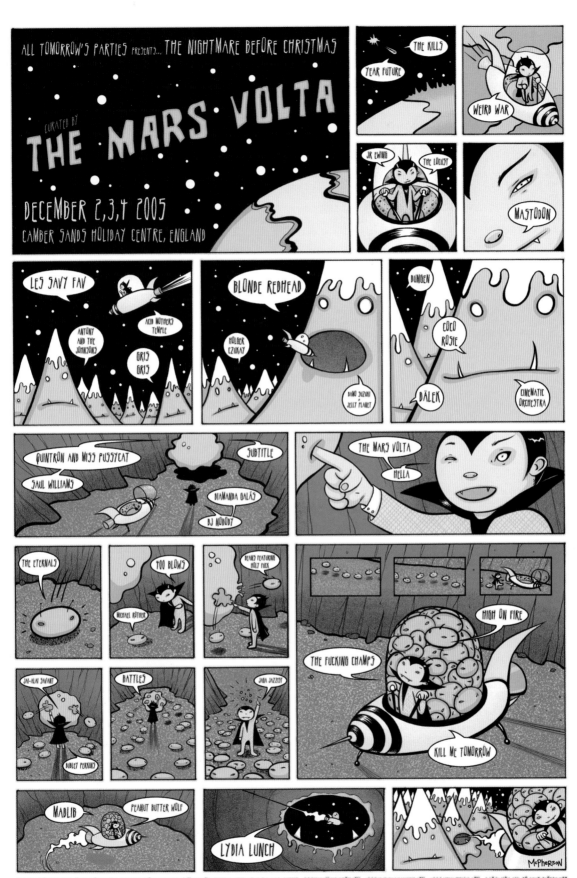

ALL TOMORROW'S PARTIES: CURATED BY THE MARS VOLTA - four-color silkscreen, 16" x 23", edition of 300, 2005

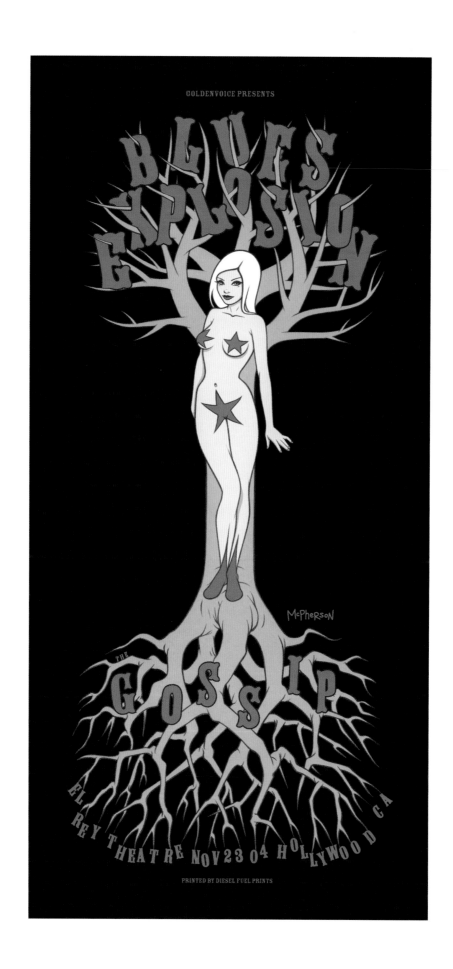

BLUES EXPLOSION, THE GOSSIP - five-color silkscreen, 12" x 25", edition of 400, 2004

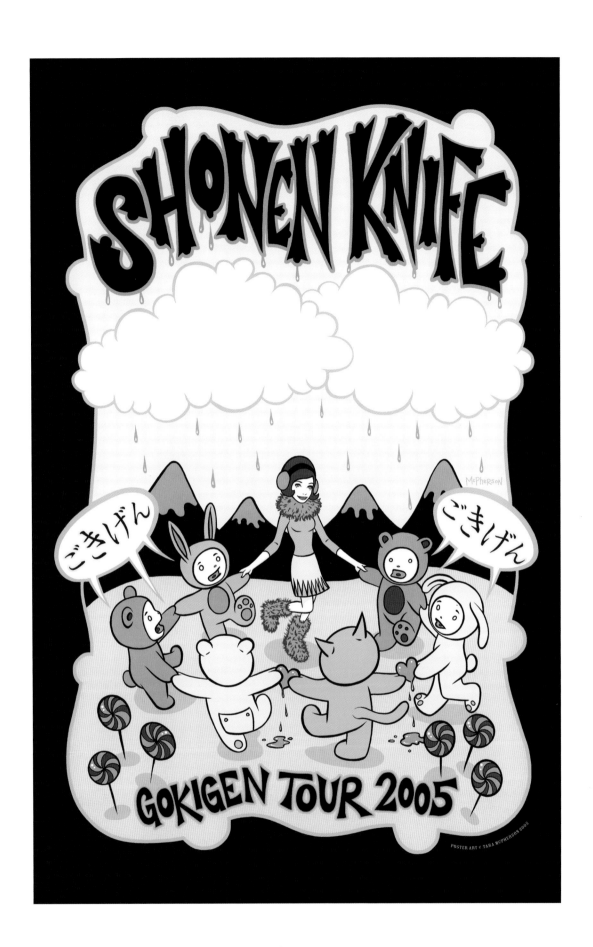

SHONEN KNIFE - six-color silkscreen, 23" x 32", edition of 300, 2005

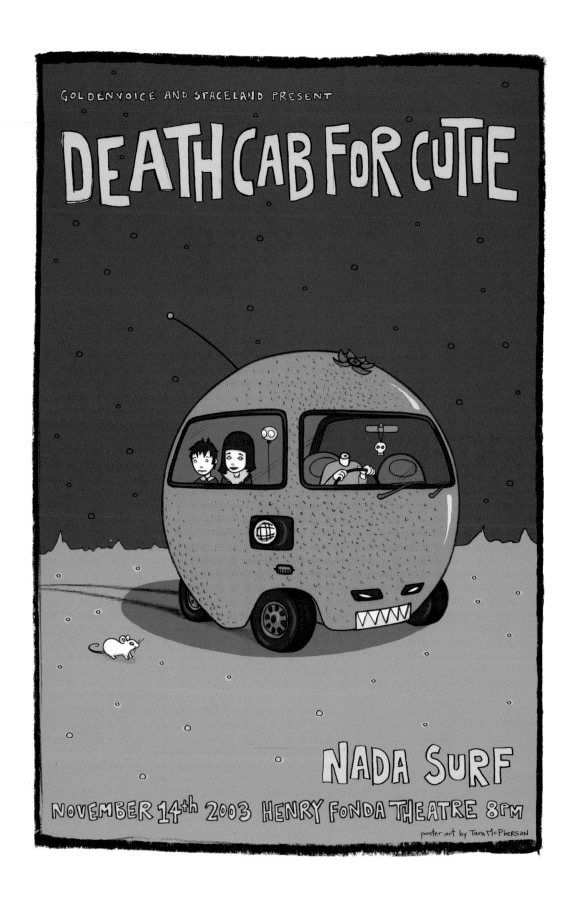

DEATH CAB FOR CUTIE, NADA SURF - offset print, 12" x 18", edition of 300, 2003

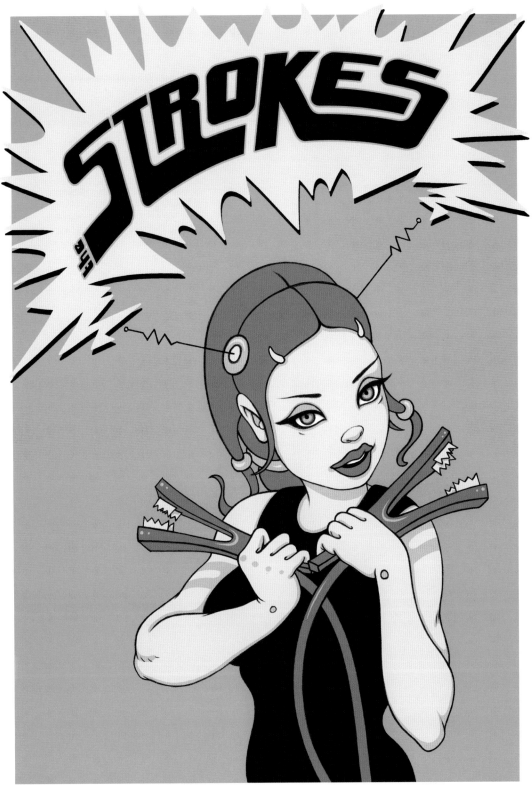

THE STROKES, KINGS OF LEON, REGINA SPEKTOR - offset print, 12" x 18", edition of 300, 2003

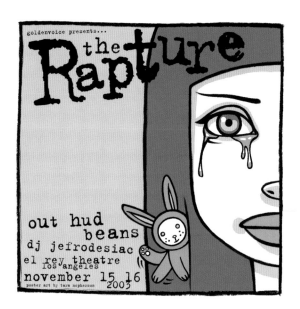

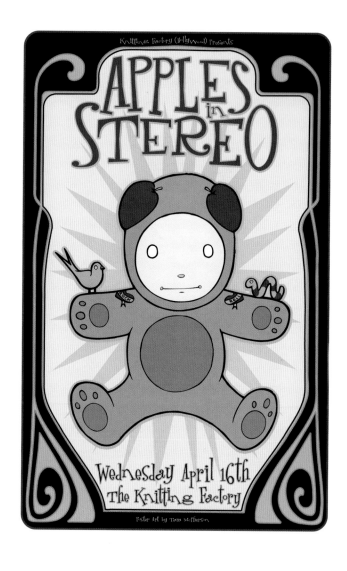

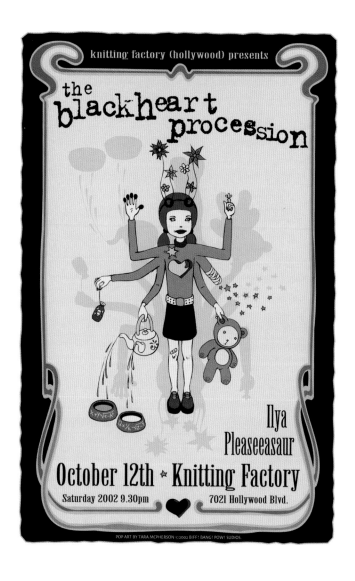

THE RAPTURE, OUT HUD, BEANS - four-color silkscreen, 13" x 13", edition of 96, 2003
THE BLACK HEART PROCESSION, ILYA, PLEASEEASAUR - offset print, 11" x 17", edition of 300, 2003
APPLES IN STEREO - offset print, 11" x 17", edition of 300, 2003

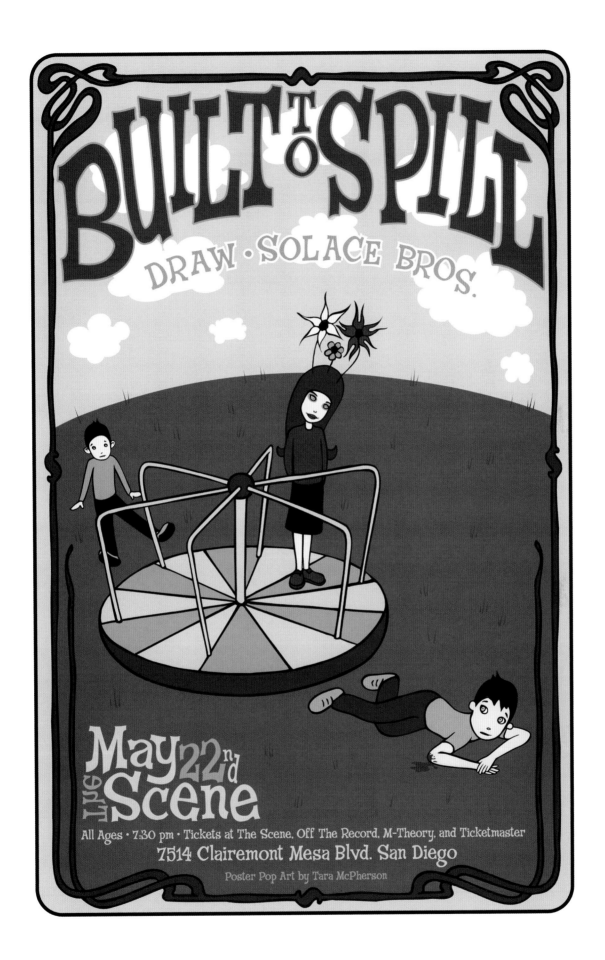

BUILT TO SPILL, DRAW, SOLACE BROS. - nine-color silkscreen, 19" x 30", edition of 150, 2003

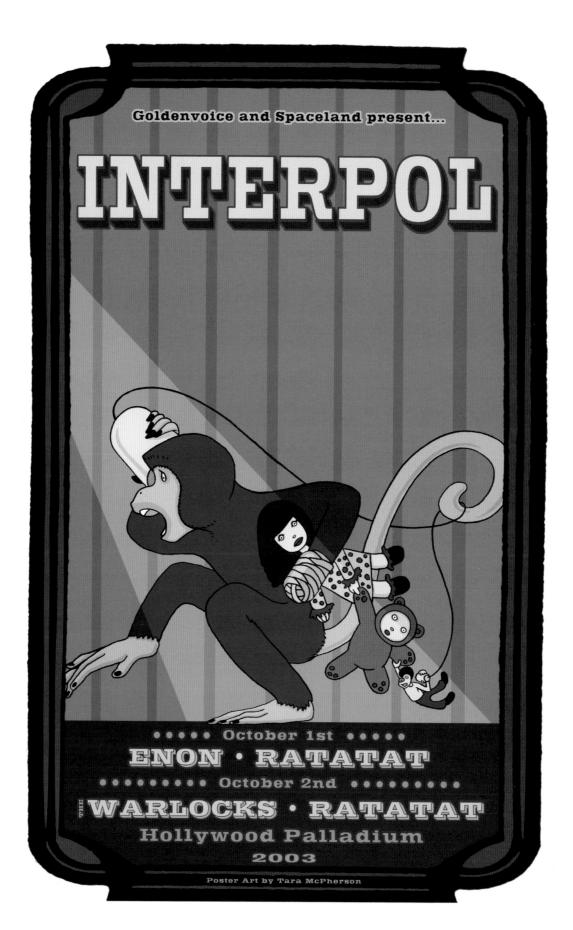

INTERPOL, ENON, THE WARLOCKS, RATATAT - offset print, 11" x 17", edition of 300, 2003

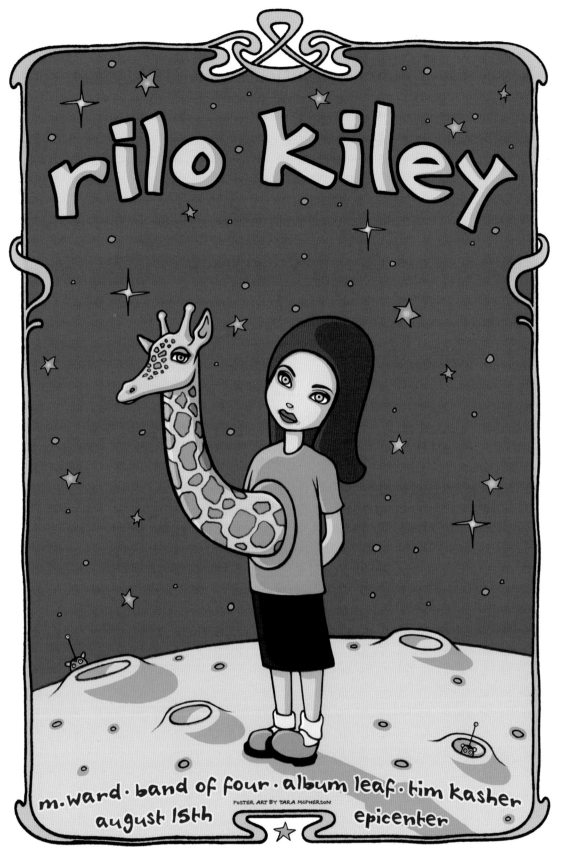

RILO KILEY, M.WARD, BAND OF FOUR, ALBUM LEAF, TIM KASHER - offset print, 11" x 17", edition of 300, 2003

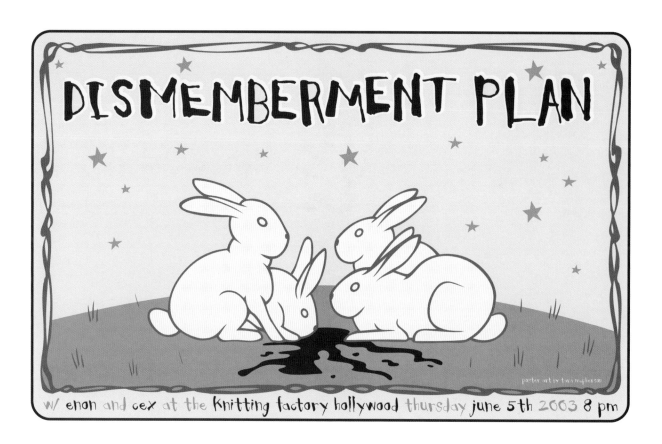

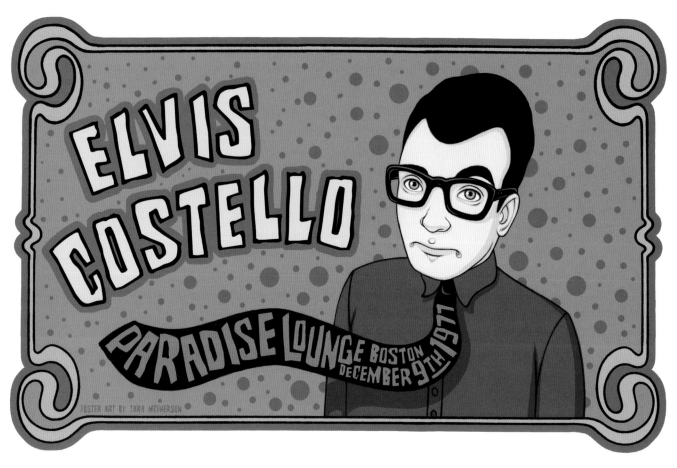

DISMEMBERMENT PLAN, ENON, CEX - offset print, 11" x 17", edition of 300, 2003
ELVIS COSTELLO - offset print, 11" x 17", edition of 500, 2003

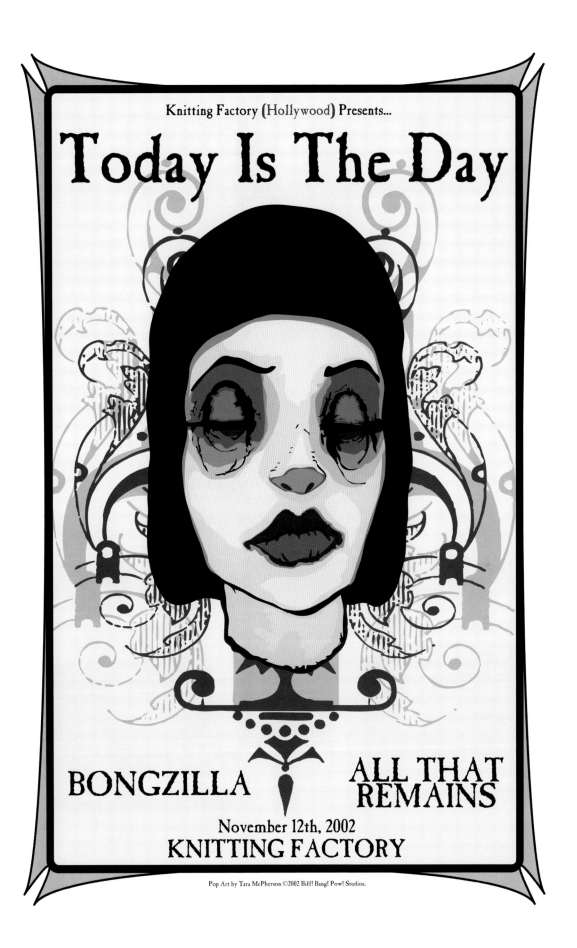

TODAY IS THE DAY, BONGZILLA, ALL THAT REMAINS - offset print, 11" x 17", edition of 300, 2002

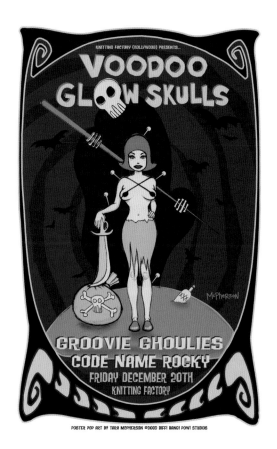

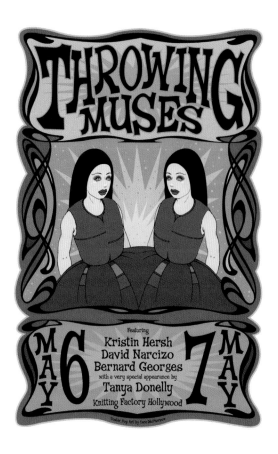

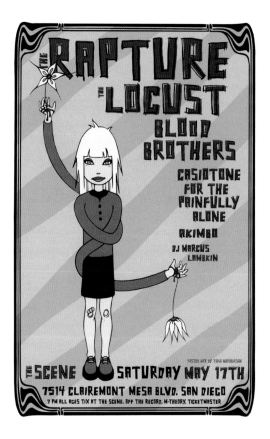

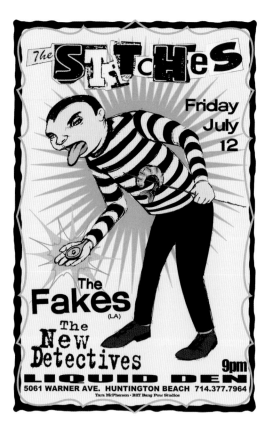

VOODOO GLOW SKULLS, GROOVIE GHOULIES, CODE NAME ROCKY - offset print, 11" x 17", edition of 300, 2003
THROWING MUSES - offset print, 11" x 17", edition of 300, 2003
THE RAPTURE, THE LOCUST, BLOOD BROTHERS, CASIOTONE FOR THE PAINFULLY ALONE, AKIMBO, DJ MARCUS LAMBKIN - offset print, 11" x 17", edition of 300, 2003
THE STITCHES, THE FAKES, THE NEW DETECTIVES - offset print, 11" x 17", edition of 300, 2002

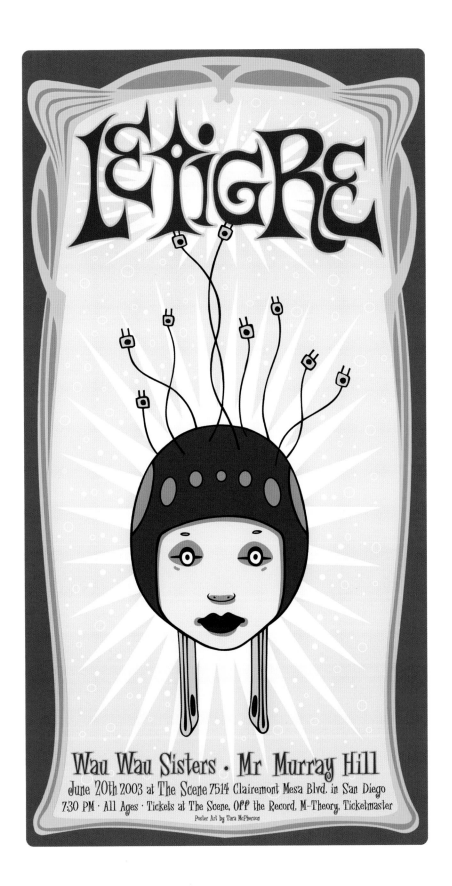

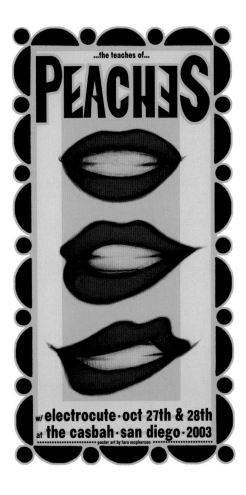

LE TIGRE, WAU WAU SISTERS, MR. MURRAY HILL - offset print, 9" x 17", edition of 300, 2003
PEACHES, ELECTROCUTE - offset print, 9" x 17", edition of 300, 2003

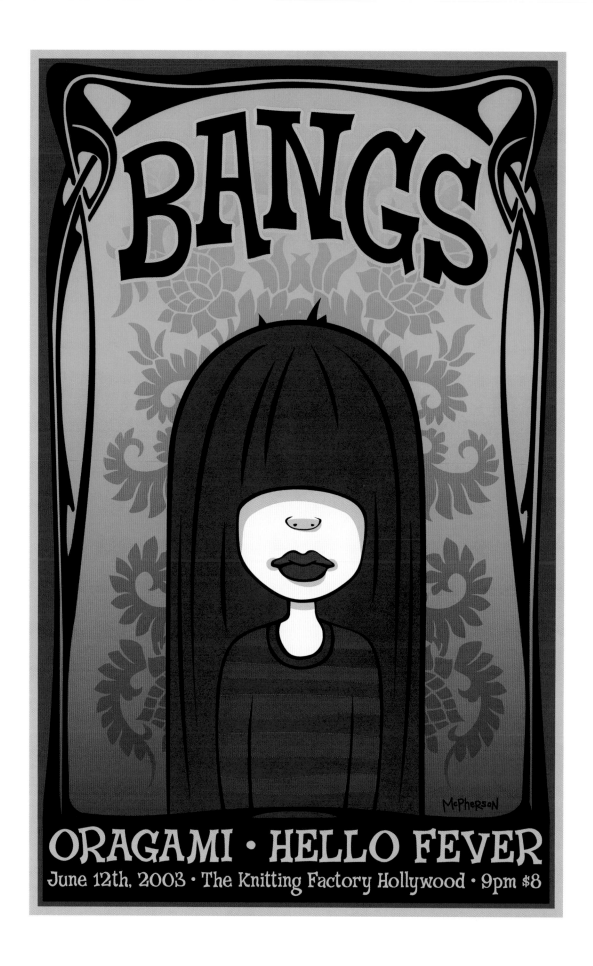

BANGS, ORAGAMI, HELLO FEVER - offset print, 11" x 17", edition of 300, 2003

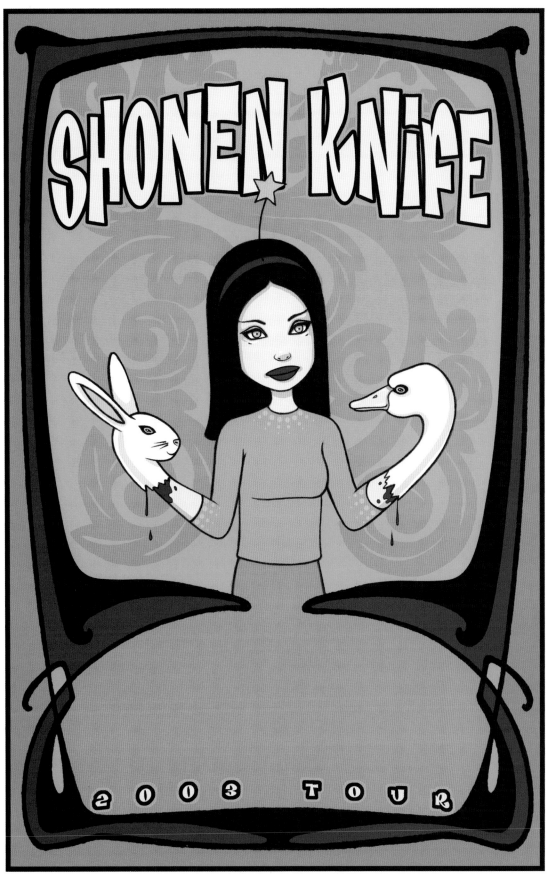

Poster Art by Tara McPherson ©2003

SHONEN KNIFE - offset print, 11" x 17", edition of 300, 2003

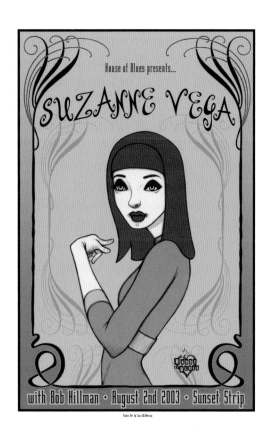

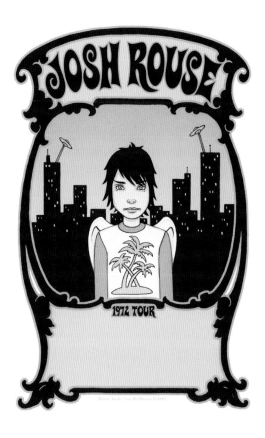

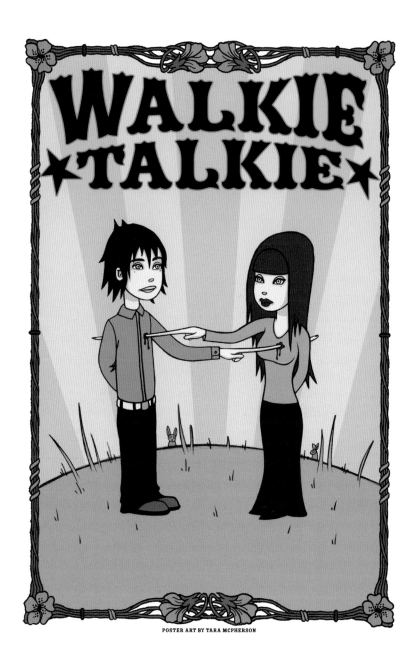

POSTER ART BY TARA MCPHERSON

SUZANNE VEGA, BOB HILLMAN - offset print, 11" x 17", edition of 300, 2003
JOSH ROUSE - offset print, 11" x 17", edition of 300, 2003
WALKIE TALKIE - offset print, 11" x 17", edition of 300, 2003

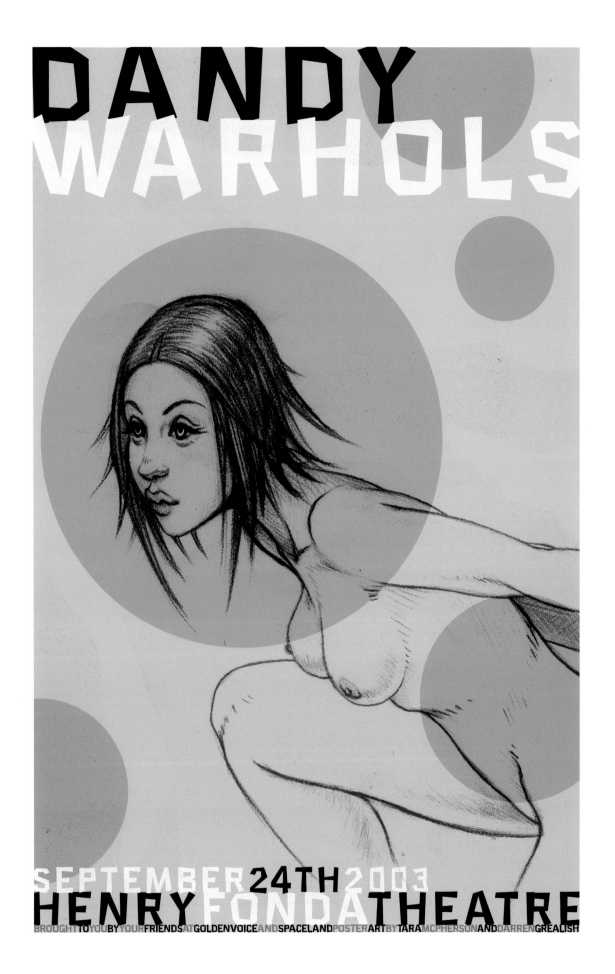

DANDY WARHOLS - offset print, 11" x 17", edition of 300, 2003

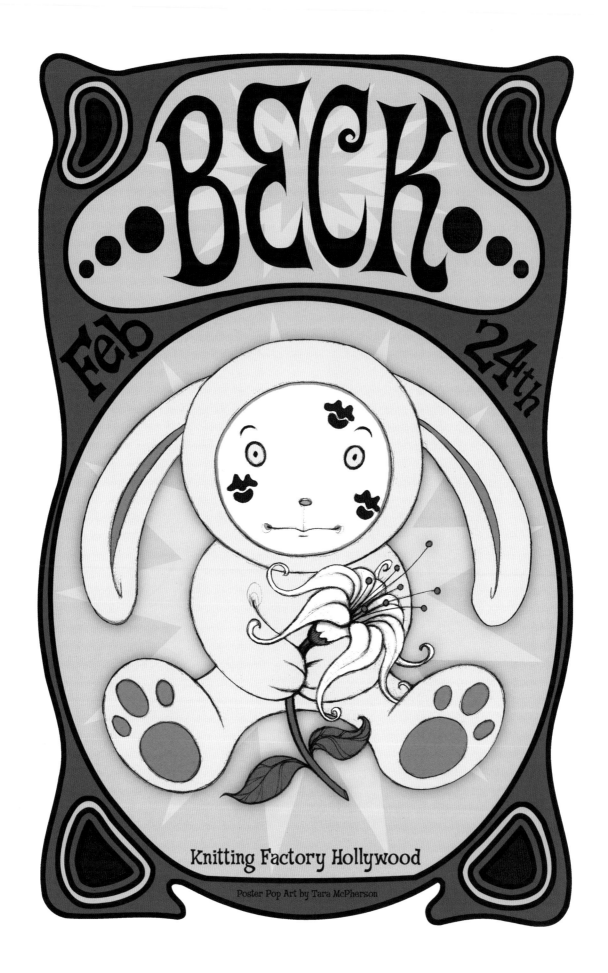

BECK - offset print, 11" x 17", edition of 300, 2003

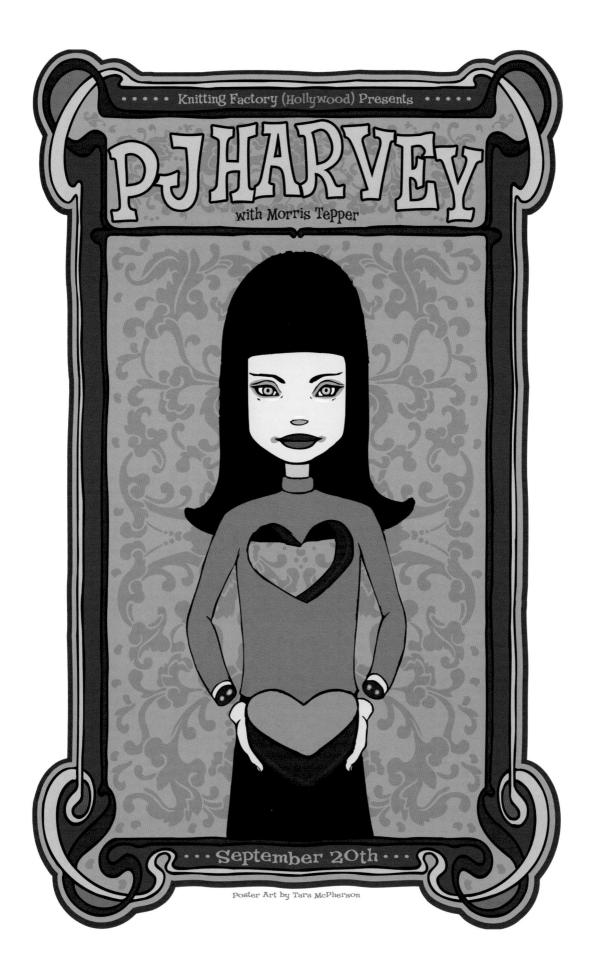

PJ HARVEY, MORRIS TEPPER - offset print, 11" x 17", edition of 300, 2003

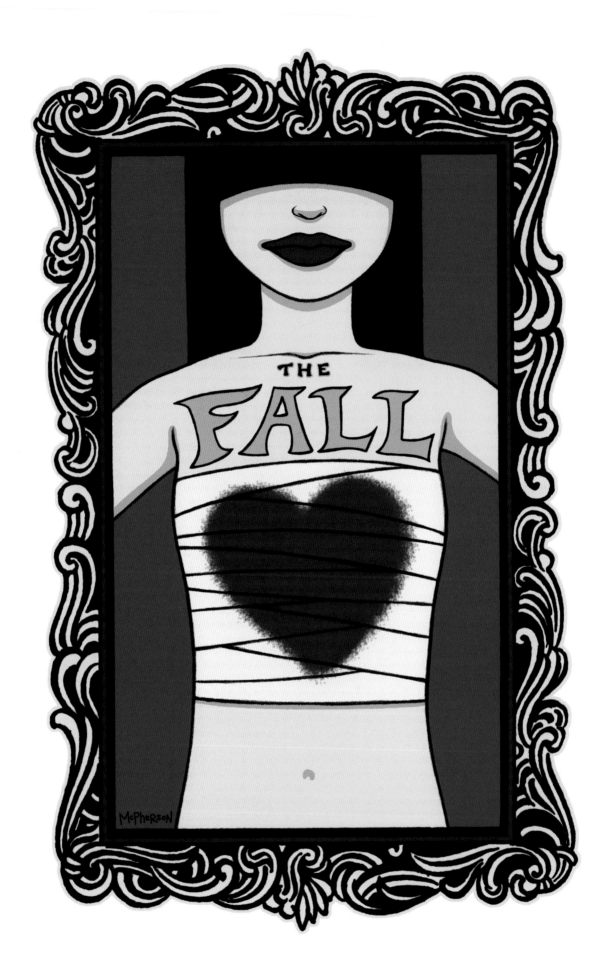

THE FALL - five-color silkscreen, 23" x 32", edition of 260, 2004

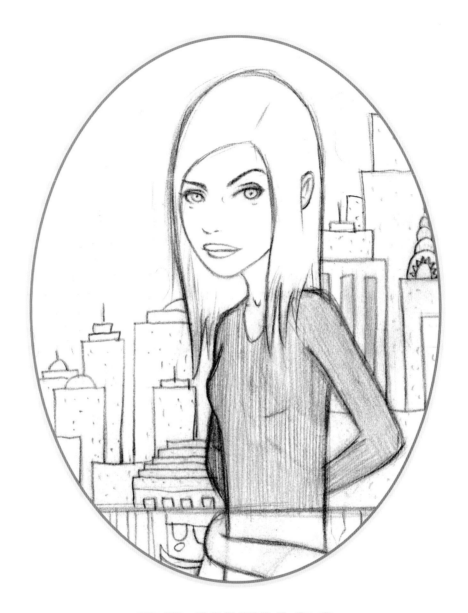

DRAWINGS

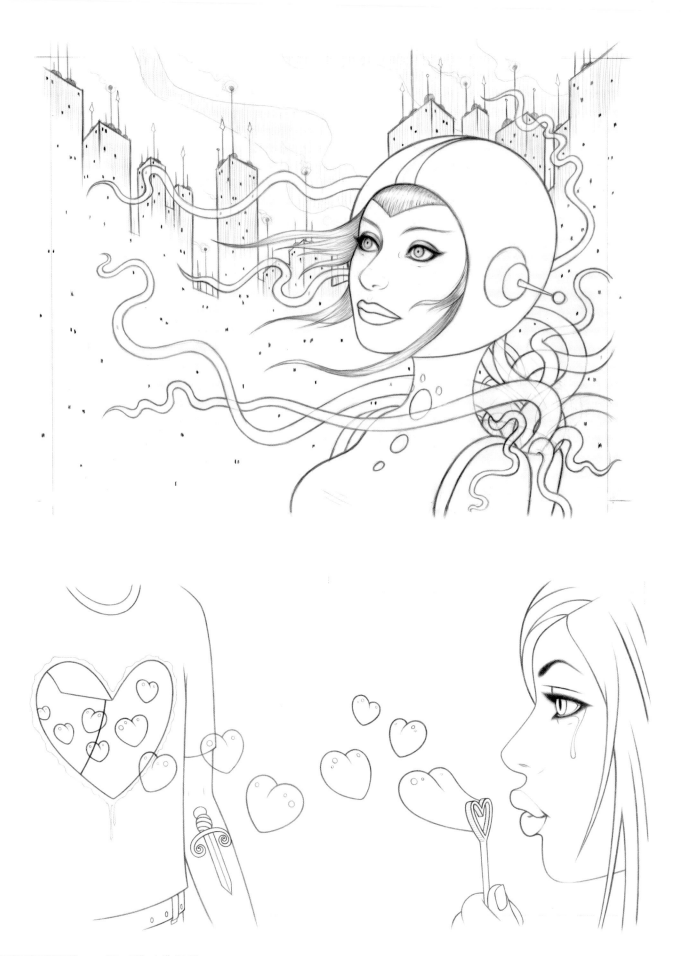

WHY DO I DO WHAT I DO - graphite, 17" x 14", 2005
LOVE BLOWS - graphite, 17" x 14", 2005

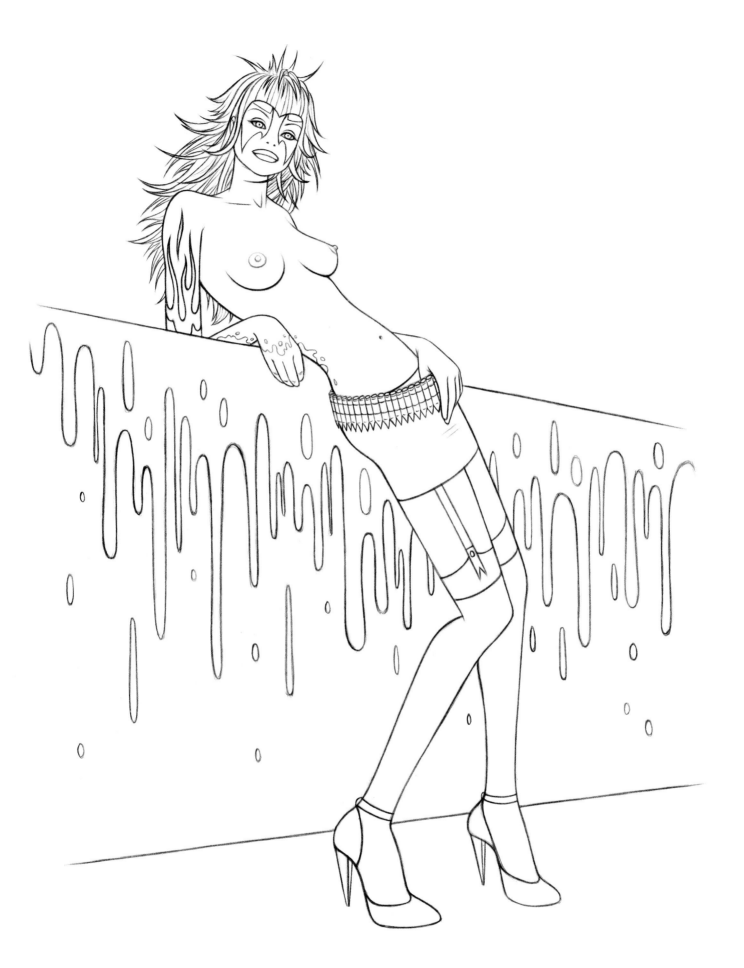

HIGH ON FIRE - graphite, 14" x 17", 2006

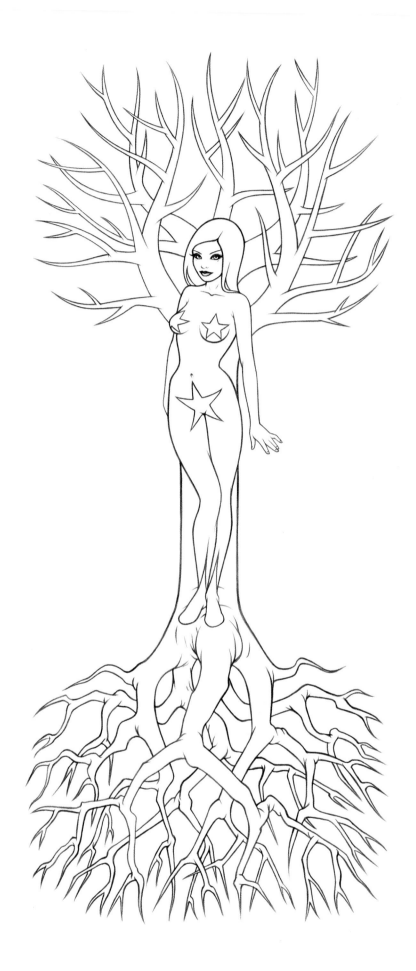

BLUES EXPLOSION - graphite, 14" x 17", 2004

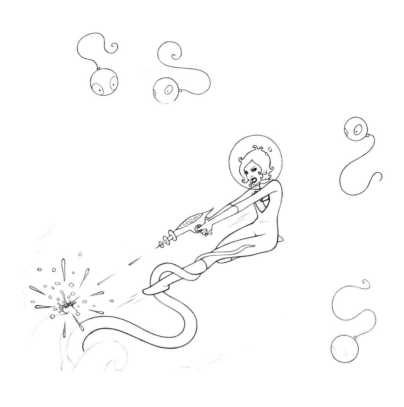

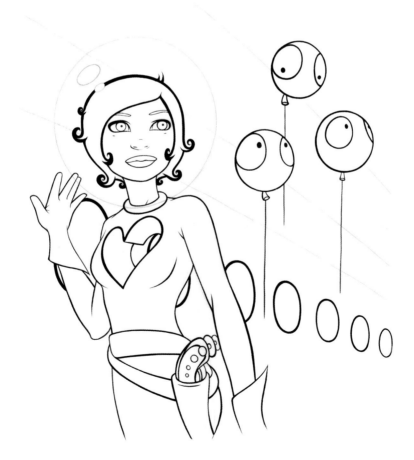

GREEN DAY - graphite, 14" x 17", 2005
THE DULL SOUND - graphite and india ink, 14" x 17", 2005

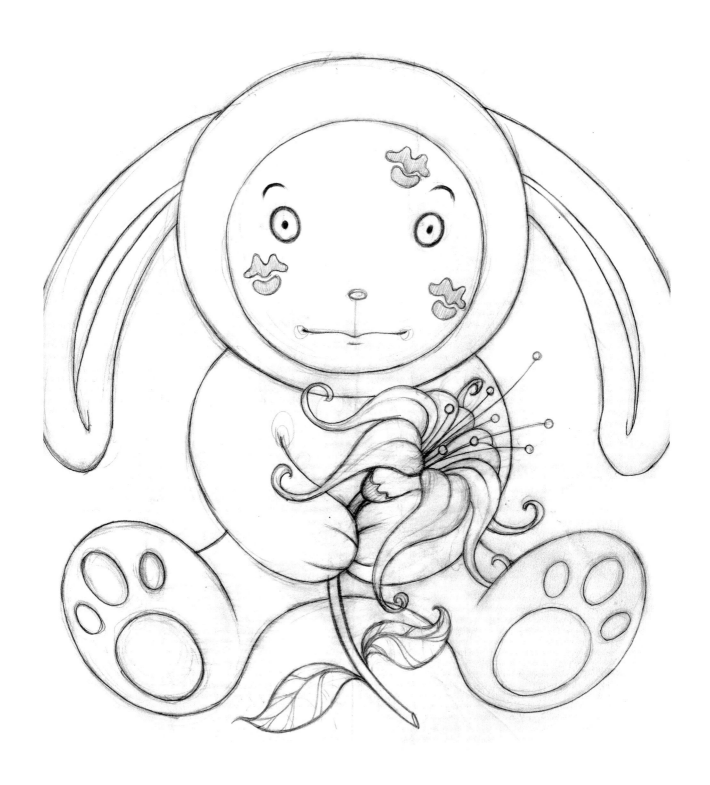

ION - graphite, 11" x 14", 2002

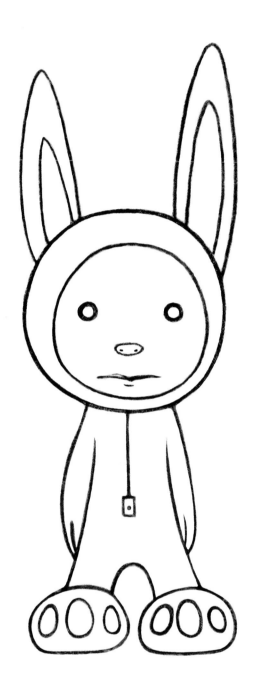
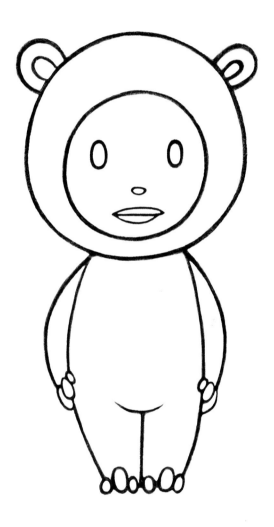

ION - graphite, 3" x 5", 2001
ACE - graphite, 3" x 5", 2001

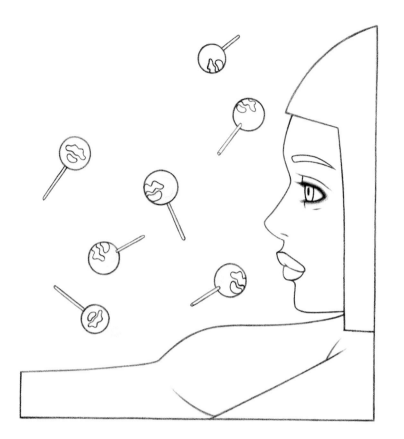

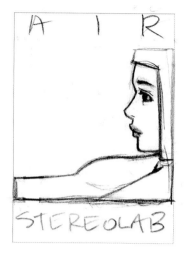

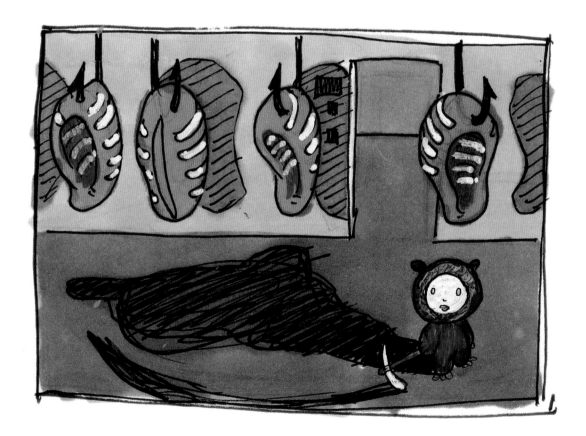

AIR - graphite, 8.5" x 11", 2004
AIR (rough) - graphite, 2" x 4", 2004
MEAT LOCKER (rough) - pen and marker, 3" x 5", 2000

LIGHT HEARTED AND DARK HEARTED - graphite, 10" x 5", 2002
GIRL HEAD - graphite, 1" x 3", 2003
BOY HEAD - graphite, 1" x 3", 2003
GIRL HEAD - graphite, 1" x 3", 2003

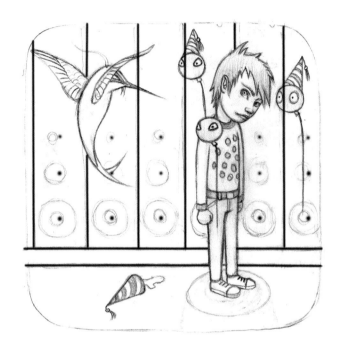 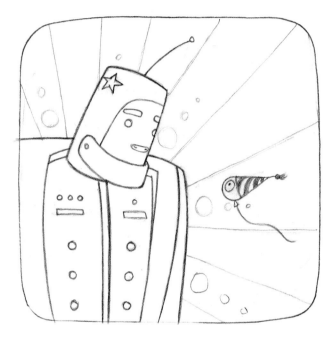

FIGHT THE FLIGHT OF ATTACK - graphite, 5" x 5", 2003
DEFEND THE FIGHT - graphite, 5" x 5", 2003

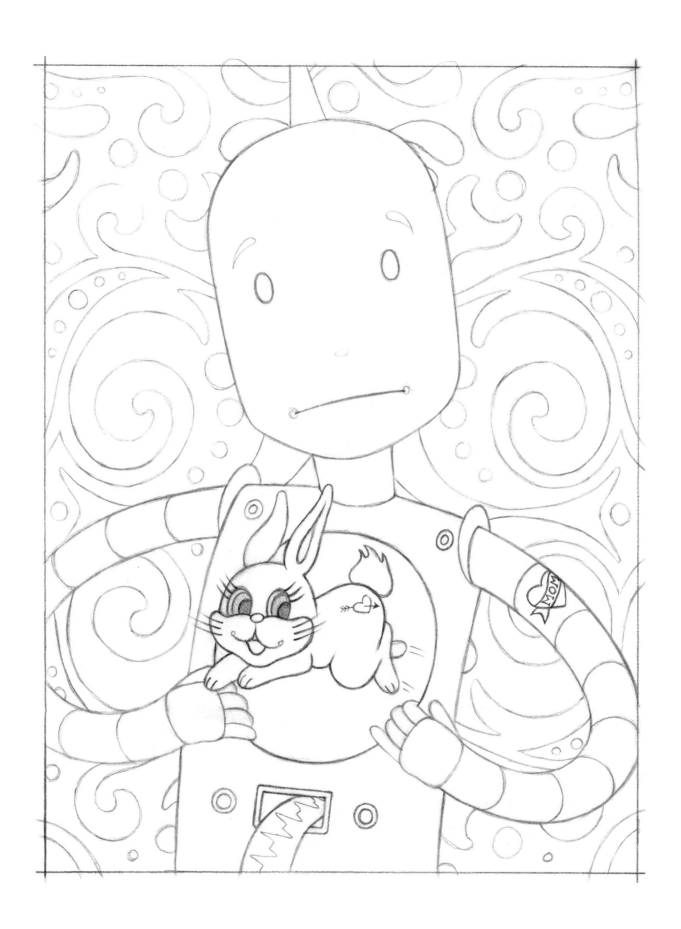

LONELY HEARTS GANG PART 2 - graphite, 11" x 14", 2002

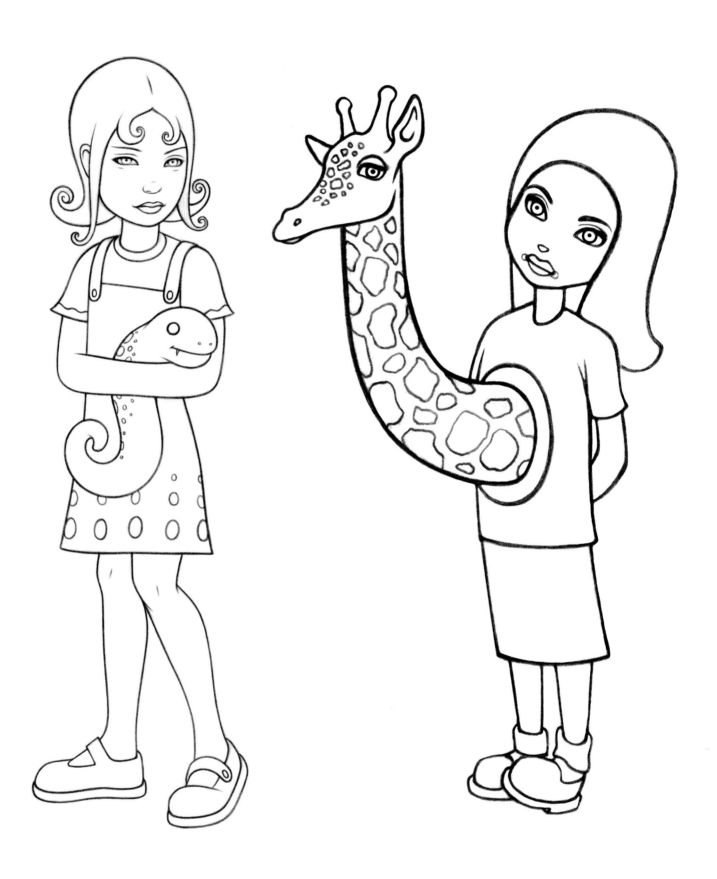

QUEENS OF THE STONE AGE - graphite, 5" x 10", 2005
RILO KILEY - graphite, 3" x 6", 2003

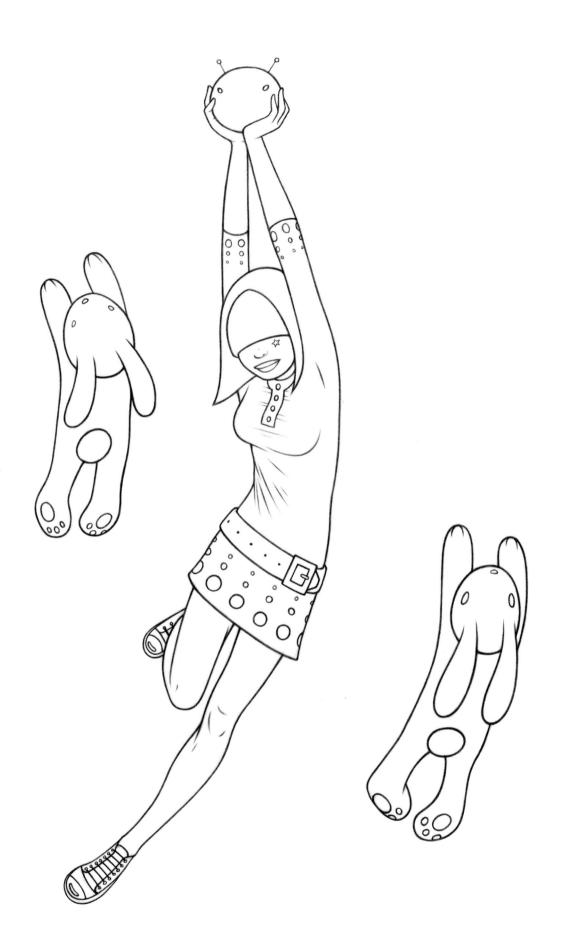

BRIGHT EYES - graphite, 14" x 17", 2004

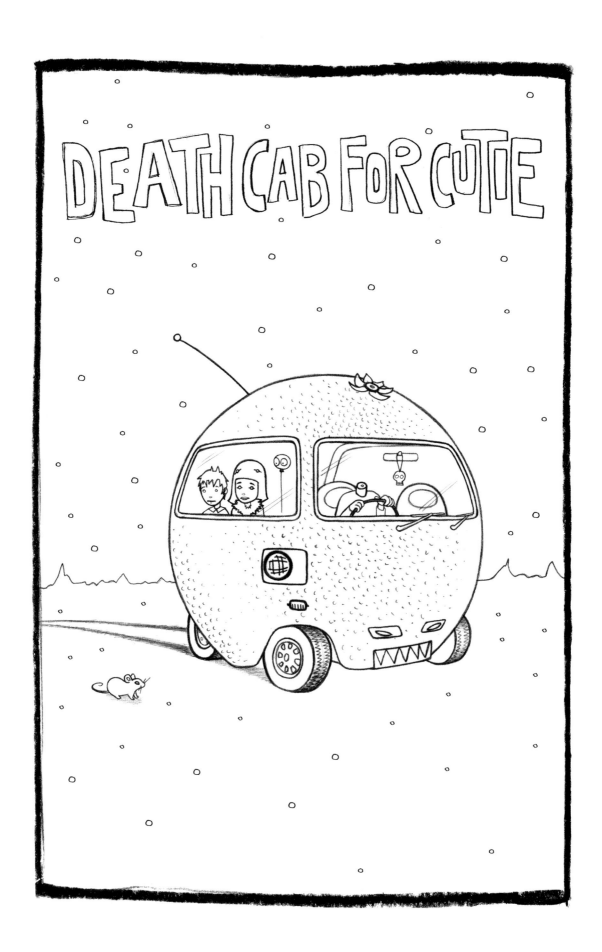

DEATH CAB FOR CUTIE - graphite, 8.5" x 11", 2003

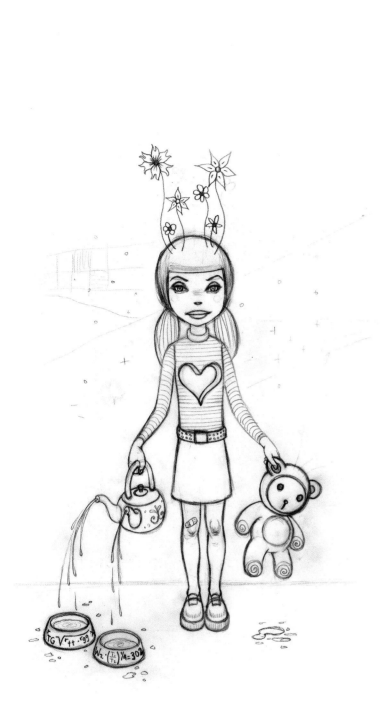

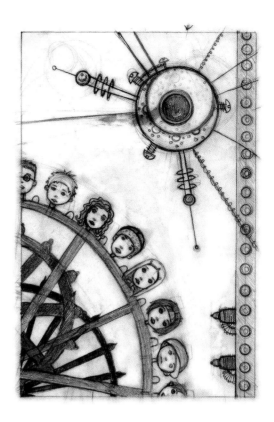

TEA GIRL - graphite, 8.5" x 11", 2002
MY LOST CHILDREN - graphite, 11" x 14", 2000
WALKIE TALKIE - graphite, 8.5" x 11", 2003

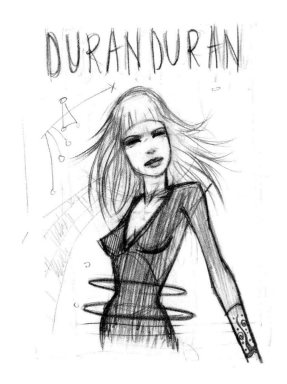

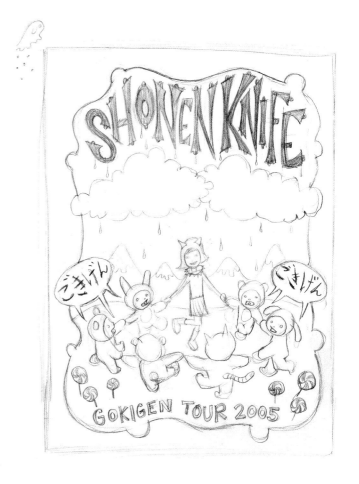

DURAN DURAN (rough) - graphite, 4" x 6", 2004
JOSH ROUSE - graphite, 8.5" x 11", 2003
BLACKHEART PROCESSION - graphite, 8.5" x 11", 2002
SHONEN KNIFE (rough) - graphite, 8.5" x 11", 2005

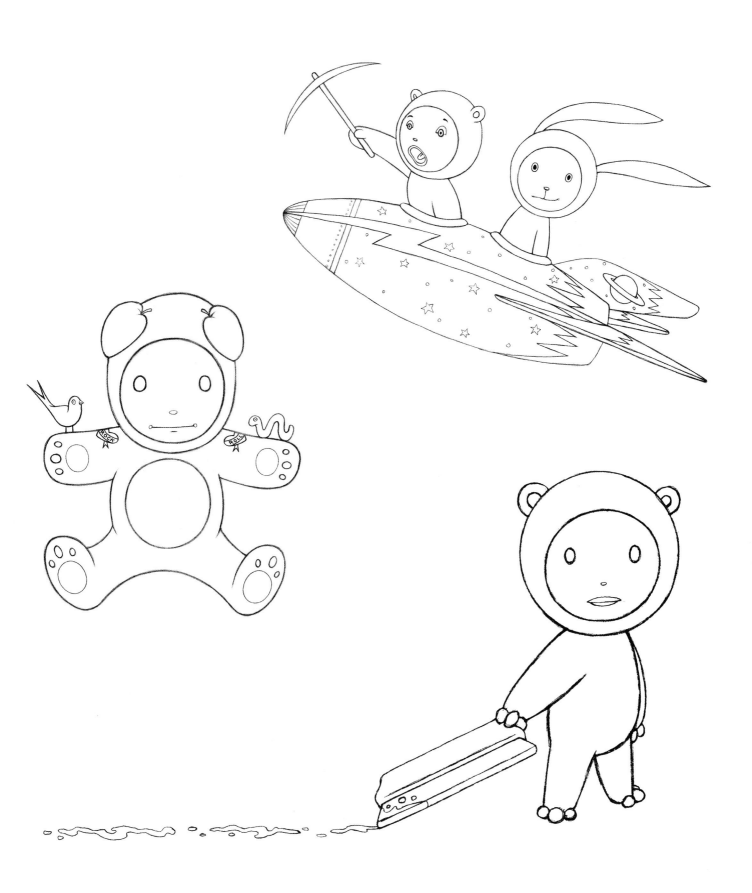

BEAR - graphite, 5" x 5", 2003
ACE AND ION GO SPACE MINING - graphite, 11" x 14", 2002
SQUEEGEE ACE - graphite, 3" x 5", 2002

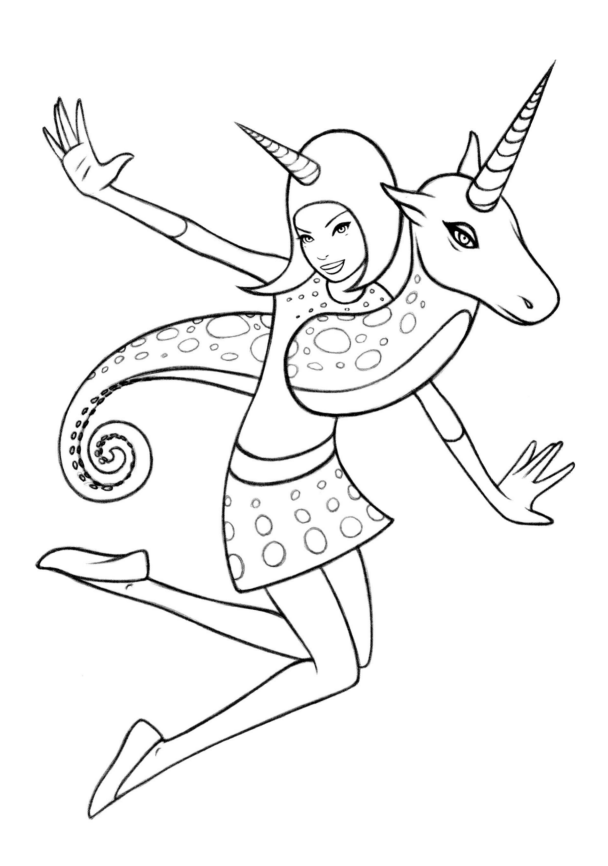

FLYING UNICORN GIRL - graphite, 7" x 7", 2006

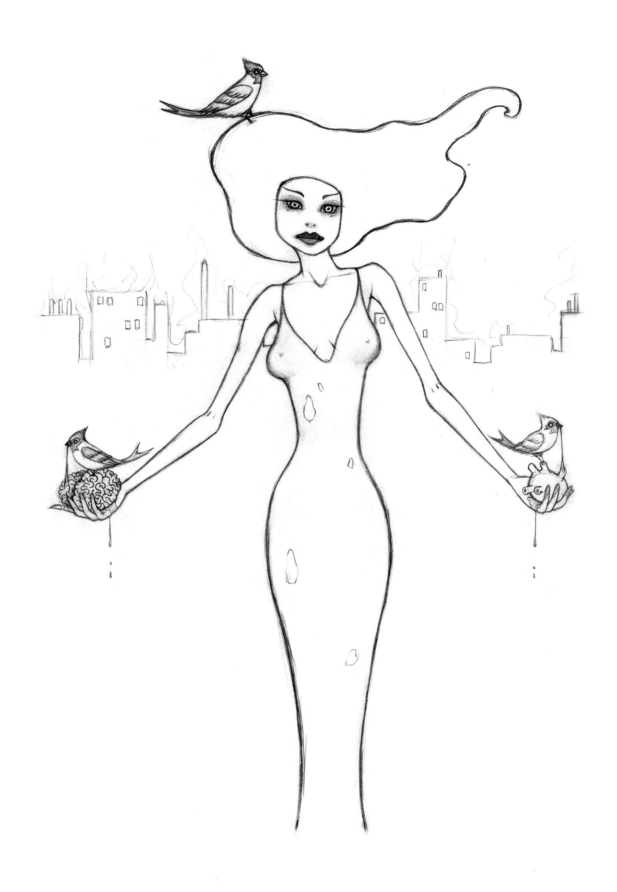

ZOMBIRELLA - graphite, 11" x 14", 2002

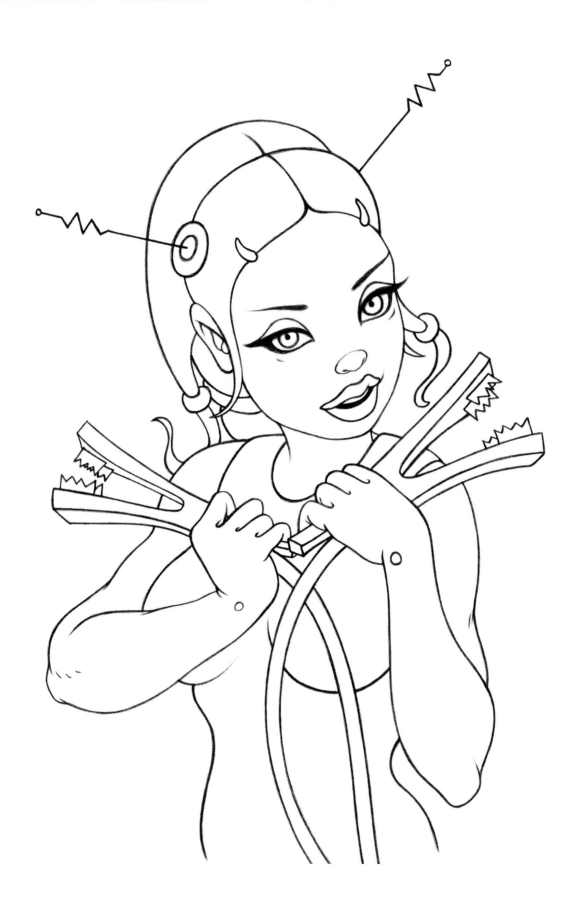

THE STROKES - graphite, 11" x 14", 2003

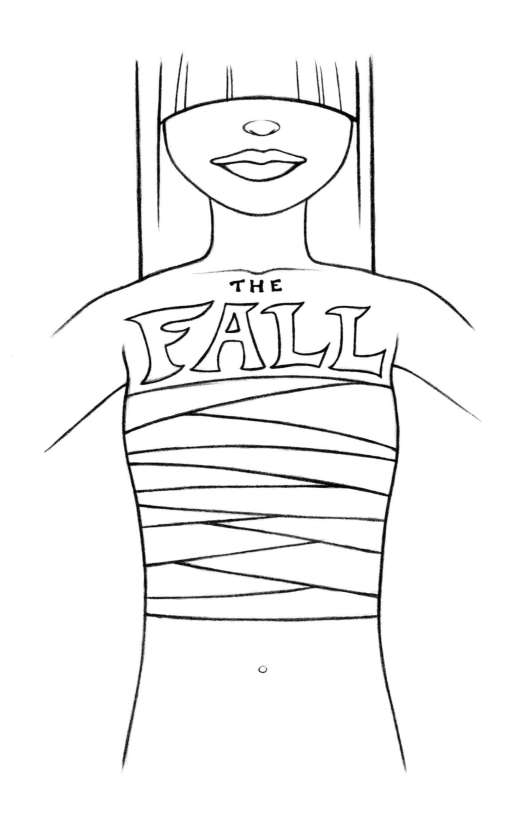

THE FALL - graphite, 8.5" x 11", 2004

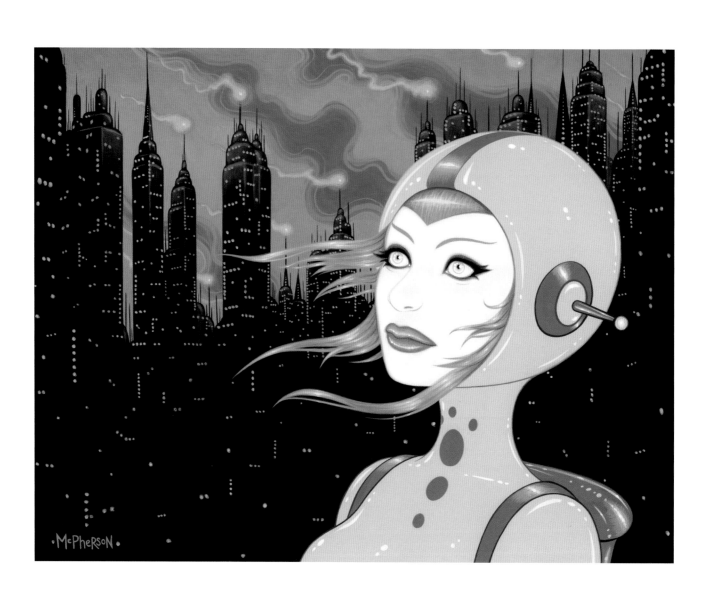

WHY DO I DO WHAT I DO - acrylic, 18" x 14", 2006

INTERVIEW

How did you get started? What's the first thing you remember drawing?

I've been interested in art my entire life, so I can't remember a time when I wasn't interested or a specific moment where I became interested in art. I've always done it and always felt the need to do it. The first time I remember drawing is on the kitchen walls when I was about three. My parents were going to re-wallpaper the whole kitchen, so for weeks they let me draw all over the walls with crayons. So from my first memory I was given a lot of freedom to create. I started going to art magnet schools from elementary school on. I was making stained glass windows in seventh grade and developing my own film and printing in a darkroom by tenth grade. I got to a point when I was at Fairfax High School where I was completely bored with what they were teaching. I had a very strong desire to learn, but wasn't being challenged enough in that environment, so I took the High School Proficiency test at sixteen and when I turned seventeen I started going to Santa Monica Community College. Oddly enough, when I started there I got really enthralled with astrophysics. The complexity and vastness of the universe simply boggles my mind and piques my curiosity. I was even vice-president of the Astronomy Club! I had done art my whole life, but I think when I got really fascinated with astronomy I needed a break from art, and I went in the complete opposite direction sort of as a backlash against all the art I had done. I was pursuing that for a while and then had a realization one day that I didn't think I'd be happy sitting in an observatory logging data in the middle of the night (now, I do artwork by myself in the middle of the night, go figure). At that time I was managing a Japanese anime/toy/art store in West LA called Banzai Anime, and that turned me on to so many new and different artists. I was at a point where I was ready to be serious about creating art again. I then decided to work on my portfolio to transfer to an art school. I knew I wanted to be an illustrator. I began taking all the art classes at SMCC, everything from Printmaking to Serigraphy to Drawing. When I applied to Art Center my portfolio consisted mainly of limited edition prints: woodcuts, etchings, linocuts, and screen prints.

I know you often work twelve or fifteen hour days. What's a typical day for you?

I do work a lot and really late. An average perfect day for me would be to wake up about 11 A.M., go on a short walk to grab coffee, draw or paint for a few hours, grab lunch and run errands and try to enjoy the outside world a tiny bit, come back and draw or paint until about 2 A.M., meet up with friends for a nightcap, and then get to sleep around 4 A.M. This is an ideal day though . . . sometimes I don't leave the studio for three days at a time and don't see anyone except for my UPS delivery guy. I've found the success is in balance: work hard, play hard. I find it very easy to obsess on my art and not go out anywhere, so it's important for me to remember to let my mind breathe a little to find new inspiration.

How many projects do you work on in a given week?

It completely depends on what's on my plate. An average week would be at least five. Paintings take me longer to do, say a week or three. If I'm doing a poster, or a drawing for an art print, that'll go faster, maybe two or three days. Sometimes I can get a job done in half a day, sometimes it'll take me a month—it completely varies. I'm starting a graphic novel for DC/Vertigo Comics next month which is going to take me a year to do because I'm going to be painting the entire hundred-page comic myself. But I'll be working on lots of other projects while doing that. Most things overlap.

Because I run my own business, my responsibilities also entail everything from emailing to phone calls to shipping. It's that side of being an artist that a lot of people don't realize happens. It's the boring part, but the part that also has to get done. But ultimately it's always different—there are new jobs, new formats, and new challenges that constantly keep me entertained.

How does an illustrator develop a style so that it doesn't become stale for themselves and out-of-step with what clients want?

All artists go through a natural evolution. The key thing for me is to constantly challenge myself to experiment and be aware. Constantly observe people and things in life, try to perceive things in new and different ways, and transform them. Take a step back so you can step forward. Most of the time when I am working I see no clear distinction between my commercial and gallery work. One can be used for the other and vice versa without hesitation. And that blurring allows me to be honest with my art no matter in what arena it is intended to be viewed. That in turn makes the work relatable . . . people understand and are drawn to the imagery. The client is happy and I'm happy.

You just debuted your Lonely Hearts stationery set. What's interesting to me is that you take a general theme, brokenheartedness, and take it to a new extreme, but it still

connects. How did that come about, and can you elaborate on your inspiration?

My art has always had a very strong personal essence to it. What I go through emotionally and observe people going through has a significant effect on my art, conceptually speaking. It's cathartic for me to create my art. I get through my emotional turmoil by drawing and painting images. It is a necessity for me to contemplate ideas through that catharsis. Romantic disasters are a very powerful source of inspiration, whether they belong to my friends or me. The stationery set's main character, Orian, is a very strong woman, and you can tell she has a dynamic personality. She's not depressed, she's an empowered female character who has survived emotional turmoil.

You do a lot of concert posters. How did you get your start making them and who commissions you?

After I graduated college in 2001, I finally had the free time to do certain things I wanted to do. Playing in a band again was one of the first things I did. When we needed fliers for our shows I was usually the one to make them. I started out with little quickie black and white xeroxes, then they evolved into more detailed color prints. I was having so much fun making them, and realized that I could possibly include making rock posters as part of my freelance illustration work, so I asked the promotions and publicity person at the Knitting Factory in Hollywood if they would be interested in having posters made for some of their shows. They said yes and we agreed on a fee to cover the printing and art. It all grew from there . . . I began doing posters for Goldenvoice, House of Blues, and various tour posters.

A commission can come through a venue, a band, another artist, a label, or a booking agent. But no matter where the commission comes from, I always get the band's permission to make and sell the poster. The art fee varies from job to job. As far as imagery goes, I'm given complete freedom to create what I want, which is how I work best. The venue will get ten to twenty posters to use as promotion, the band will get thirty to a hundred posters to sell, and I keep the rest of the run to sell myself.

What's the process of working on the posters like?

I do some writing and brainstorming in the beginning stages. I think about what their music is about, what they stand for, what connotations come to mind when I listen to their music, and how I can interpret their sound visually. That's why it helps me to write first before I start sketching. I'll make word associations to get ideas and a strong concept. From there I'll do rough sketches; by then I usually have a pretty good idea of what I want to do with the poster. I'll then make my final drawing or inking, scan it, and do the color separations in PhotoShop, where each color is on it's own layer. To get the colors right I use Pantone swatches for the color-matching system. I FTP the file over to my screen printer, Diesel Fuel Prints, who outputs the films and begins printing.

Do you have a favorite poster you've done so far?

It's usually my newest poster, though I love all of them in their own special ways. They're all my little babies.

Does it feel more special to do limited editions?

I had gotten used to paintings, where there's just the single object, but when I got into doing art prints and poster editions again, I thought it was really great that I could offer something that's nowhere near as expensive as a painting. Something an

TARA'S TOOLS

Paints
- Golden Heavy Body Acrylics
- Windsor & Newton Oils
- Daniel Smith Oils
- Gamblin Oils

- Alizarin Crimson
- Anthraquinone Blue
- Burnt Sienna
- Burnt Umber
- Cerulean Blue Deep
- Chromium Oxide Green
- C.P. Cadmium Red Light

- C.P. Cadmium Red Medium
- C.P. Cadmium Red Dark
- C.P. Cadmium Yellow Light
- C.P. Cadmium Yellow Dark
- Carbon Black
- Cobalt Blue
- Cobalt Turquoise
- Dioxazine Purple
- Hookers Green Hue
- Jenkins Green
- Manganese Blue Hue
- Paynes Gray
- Quinacridone Violet

- Raw Umber
- Titan Buff
- Titanium White
- Transparent Yellow Iron Oxide
- Turquois (Pthalo)
- Violet Oxide

Pencils
- Pentel Twist Erase - 0.5 mm
- Pentel Hi-Polymer Super Lead C505 0.5 mm - 2B, HB, 2H
- Pentel Lead 0.5 mm - Red, Blue

- Staedtler Marsmicro Polycarbon Lead 0.5 mm - 2B, HB, 2H
- Prismacolor 1298 - Non Photo Blue

Inks
- Speedball Black Pigmented Acrylic Ink
- Higgins Black Magic

Brushes
Windsor & Newton, Series 7
- Finest Sable - 00, 0, 1, 2, 4

average person could afford. It's not elitist. Also, if people know there's only a hundred of something made and they're signed and numbered by the artist, the piece feels more like an original piece of art than just a print. It's special.

Do you ever get feedback from the bands themselves?

Sometimes, and it's great when I do. Most of the posters I make are for bands I like, so it's great to be able to trade art with them, so to speak. It's even better when it's for a local show that I get to go to.

How do music and art interact in your life? Are they separate, or does one fuel the other?

I think they work very well together and inspire one another. Although I think I'm a better artist than I am a bass player, I feel the personal necessity to do both. I have to create art and I have to create music. No ifs, ands, or buts. I've been playing bass since I was fifteen and have always been very inspired by live music. It makes complete sense that I make rock posters now given how important music has been to me throughout my life.

What kinds of things should and shouldn't change the way you work?

Should: Life experience. Knowledge. Natural artistic evolution. Shouldn't: Another person's art. An art director. A trend.

How often do you travel, and do you like that aspect of your job?

I usually go out of town at least once a month to do a gallery show or a comic book or poster art convention. Flatstock is a rock poster expo that happens a few times a year during various music festivals like SXSW in Austin and Bumbershoot in Seattle. I have been attending those since the first one in 2002. I also get a booth at the San Diego Comic-Con every year. Because I work so much, it's great to get out of town to a new city and meet people. It's really fun.

Are there fashions in what clients want from illustrators?

There will always be trends, but I think by being true to yourself and your art, you will set the trend. I don't tailor my art to anyone. I create what my mind needs to create. I get hired to do what I do because of what I do, and how I do it. Nine times out of ten I get 100% creative freedom to do what I want. And that's how I work best. It's essential. I need to feel I have that freedom to create and experiment, or else the work becomes un-fun and cliché. And that's bad.

"Sweetly creepy" is a phrase that's been used to describe your work, and it does capture the very cute elements and also the darker, gothic side to your work. Do you deliberately seek to blend those two aspects?

Yes, I love that dynamic because it creates a certain tension in the work to where you're drawn in, but conversely subtly repulsed. Important to this aesthetic is the dualistic nature: sweet and creepy, idealized and raw, pretty and ugly. Taking two opposing forces and placing them together to create a dynamic tension. Enticing with the seductive qualities of form, ink, and paint, but then throwing an element into the mix that makes the viewer want to turn away, even though they are incapable of doing so due to the idealization of the image. This is an integral element in my work that spans both my commercial and fine art.

Princeton
- Liner 3050L - 20/0
- Round 3050R - 0, 2
- Monogram 3050M - 20/0

Grumbacher
- 4722 Finest Bristlette - 20

Robert Simmons,
Expression Series
- E51 Liner - 18/0
- E85 Round - 4, 6, 10
- E79 Deerfoot Stippler 3/8

Robert Simmons,
Fabric Master Series
- 431R Round Scrubber - 8

Robert Simmons,
Sienna Series
- SN48L Fan Blender - 6

Pens
- Sharpie Fine Point -
 Black, Silver
- Staedtler Pigment Liner Black -
 005, 01, 03, 05

- Pigma Micron Black -
 005, 01, 03, 05
- Pigma Brush Black

Easel
- Best Richeson Company -
 Giant Classic Dulce

Surfaces
- 1/2" Birch Wood -
 Gessoed and Sanded
- Strathmore Bristol -
 Smooth

Extras
- Sanford Design Kneaded
 Rubber 1225 Eraser
- Jim's Organic Coffee:
 Sweet Love Blend,
 Witches Brew

Hardware
- Power Mac G5 Dual 2.5 GHz
- PowerBook G4 15-Inch Laptop
- Apple 23" Cinema Display
- Epson Expression 10000XL -
 Graphic Arts Scanner

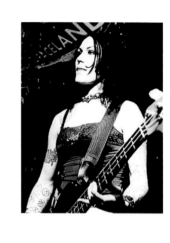

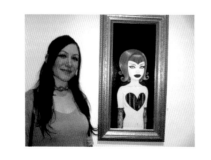

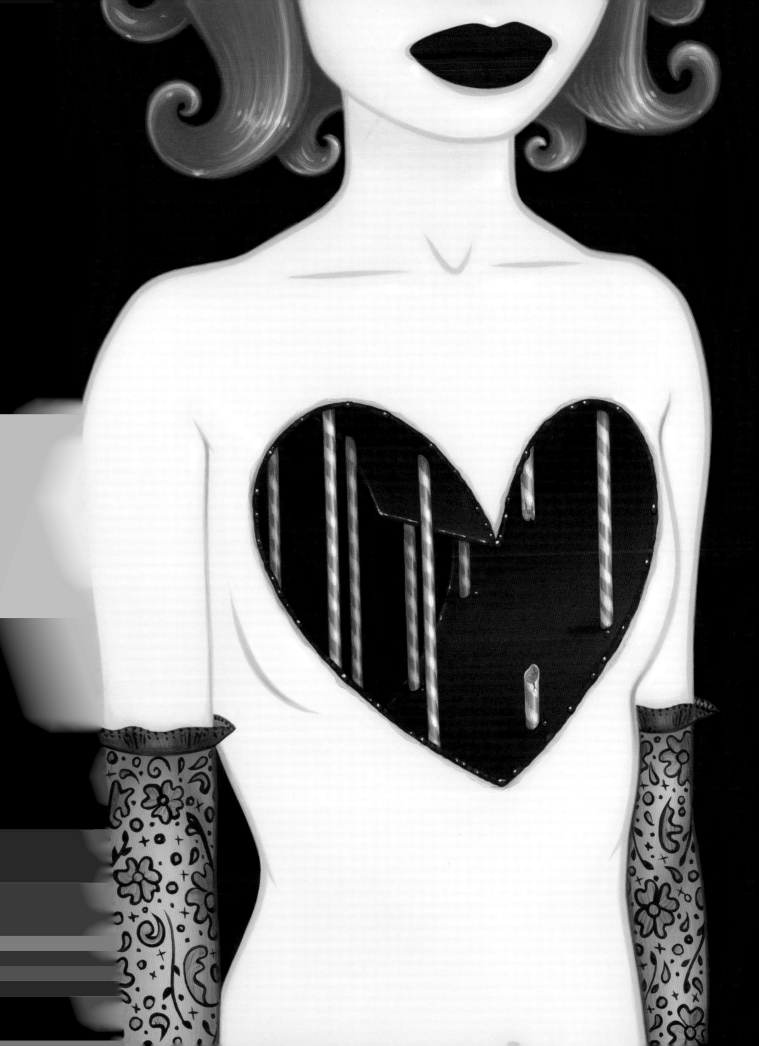